SMALL HEATH & SPARKBROOK

THROUGH TIME

Ted Rudge & Keith Clenton

To JODITIK

Best wish

Ted R AUG 2010

AMBERLEY PUBLISHING

First published 2010

Amberley Publishing Plc
Cirencester Road, Chalford,
Stroud, Gloucestershire, GL6 8PE

www.amberley-books.com

Copyright © Ted Rudge & Keith Clenton, 2010

The right of Ted Rudge & Keith Clenton to be
identified as the Authors of this work has been
asserted in accordance with the Copyrights, Designs
and Patents Act 1988.

ISBN 978 1 84868 135 4

British Library Cataloguing in Publication Data.
A catalogue record for this book is available from
the British Library.

Typeset in 9.5pt on 12pt Celeste.
Typesetting by Amberley Publishing.
Printed in the UK.

Foreword

Four generations of my family were born, bred, schooled, and employed down The Lane, the Ladypool Road area of Sparkbrook. My great grandfather Richard Chinn was only eleven in the late 1870s when he moved with his widowed mother, Mary Anne, and six younger siblings from Kings Heath to White Street, just off what was then called the Ladypool Lane. As a child in the 1880s, his future wife and my great grandmother, Florence Bartlett, lived close by in Ten House Row, Queen Street. After marrying the two of them had hard times and had to do plenty of moonlight flits in and around 'The Brook' – another name for the locality – eventually settling in Studley Street and then Alfred Street.

Their youngest son, my great uncle Wal, remembered that his mom and dad 'alluded to Sparkbrook in their youth as a pretty little village, describing the open country on both sides of the Stratford Road and the River Spark running openly on the east side of Stoney Lane'. Hedgerows then grew along Ladypool Lane and these 'often provided somewhere for a "downer" in summer time to sleep off the effects of a Sunday afternoon session at the local.' These hedgerows belonged to Stoney Lane Farm of Sam Melson, who had a quaint old house, fertile fields and a small stud of horses. They all disappeared in the 1890s as new roads were cut and the district was finally urbanised.

Although these streets officially came under Balsall Heath, my family and others thereabouts saw themselves as Sparkbrook people, a district which properly began across the Highgate Road. The Ladypool Road itself was the pulsating artery of a working-class neighbourhood, drawing to it the people of the roads that ran off it. Stretching from the 'Angel' at the Stratford Road to Church Road in Moseley it was packed with shops and boasted pubs, a picture house, billiard hall, little park, fairground, chapel, and church.

The Stratford Road, from Camp Hill all along to Sparkhill, was another busy shopping thoroughfare. Across it was the rest of Sparkbrook. This included a middle-class enclave focused on Christchurch and Farm Park, and another working-class neighbourhood around Montgomery Street. To the north east of these were the boundaries of the canal and the railway, across which is Small Heath Bridge – still called the New Bridge by older folk. Small Heath itself is a large district which also embraced distinct neighbourhoods. They were also brought together by a bustling thoroughfare that was filled with shops, pubs, picture houses, a big park, library, baths, and places of worship. This was the famed Coventry Road, or The Cov as it was called.

Interestingly in the later Middle Ages, Small Heath was not so large. It fell within the manor of Bordesley and in the 1511-12 rental of the Manor was given as 'le Small Hethe on Coventry Wye'. Then it was a small piece of uncultivated heathland close to the junction of Green Lane with the Coventry Road. As late as Bacon's Map of 1882 Small Heath was shown as that locality between Kelynge Street (Tilton Road) and Saint Andrew's Road. This is now occupied by St Andrew's, the ground of Birmingham City, originally formed as Small Heath Alliance. It is likely that the original name of the football club was largely responsible for the fact that the area covered by Small Heath increased and that of Bordesley shrank. Today the district stretches

along the Coventry Road from Watery Lane to the River Cole and from Green Lane in the north to the railway lines separating it from Sparkbrook in the south.

Small Heath joined Birmingham in 1838 along with the rest of Bordesley. By the time of Pigott Smith's Map of 1855 a freehold land society had laid out an estate with Muntz Street as its focal point; and across the Coventry Road, Wordsworth Road, Lloyd Street, Glovers Road and Whitmore Road had emerged. Seven years later the more rapid urbanisation of Small Heath was encouraged by the finishing of work on the Birmingham Small Arms Company factory in a green-field site on the borders of Small Heath with Sparkbrook and Greet.

Within twenty years, Golden Hillock Farm (also known as Glover's Farm) had been built upon and the Cooksey Road locality had emerged. At the same time, the Digbys allowed the cutting of Templefield Street and others on part of the Garrison Farm Estate. By the mid-1880s, back-to-backs and other terraced housing had filled in Small Heath as far east as the line formed by Victoria Street, Muntz Street and Golden Hillock Road; whilst Ryland's Farm had become Small Heath Park.

Over the next twenty years, Little Hay Farm of the Taylors disappeared with the cutting of Waverley Road and its offshoots such as Oldknow Road; whilst Whitmore Farm also went, replaced by Henshaw Road and Cyril Road. Similarly, the Digbys authorised the laying out of the estate between Muntz Street and Aubrey Road/Saint Benedict's Road with large terraced houses for the lower middle class. Thus the district came to have two distinct localities by the time of the First World War. Yet three farms remained: Hob Moor Lane Farm which has become a recreation ground and allotments; The Dingles, close to Kingscliffe Road; and Hay Barn Farms close to Ravensdale Road. The last two fell under the sway of council housing in the 1920s.

Apart from the Small Heath Highway, the physical layout of both Sparkbrook and Small Heath has changed little but there have been major demographic changes. In the 1950s and 1960s many Irish and West Indian families settled locally; whilst today the greater part of the population is Kashmiri Brummie, although there are large numbers of Brummies from other parts of Pakistan and also from Somalia. This book then is important for capturing not only the past but the present and ensuring that neither will be forgotten in the future. I congratulate Keith Clenton and Ted Rudge on their achievement.

Professor Carl Chinn MBE

Introduction

Walking or driving round Small Heath and Sparkbrook today it would be extremely difficult to realise that less than one hundred and fifty years ago a rural landscape existed. Like most inner city districts the transition from rural to urban happened because the pace of progress demanded it. Birmingham was not alone, it happened to most large towns in the Midlands and up north. Progress demanded factories, workshops and homes mainly for the working classes; homes got built with small regard to health or comfort that we enjoy today. They lasted in most districts until the 1960s when large-scale redevelopment took place. Although some parts of Small Heath and Sparkbrook did get redeveloped, mainly where back-to-back houses existed, a lot of what remains is part of the original build.

Not all changes in these two districts have been purely structural; changes of a different nature have taken place these include, social, economic, industrial and demographic ones. Most of these changes have been captured in this publication by two Brummies; Keith Clenton who was born and raised in Small Heath and is a lifelong Birmingham City FC supporter and Ted Rudge whose working life brought him in contact with all districts of Birmingham. Both have a fascination for the history and events that took place in Birmingham and enjoy recording them through the digital media of photography and of written text.

Starting at a large area of land that has never been built over, Small Heath Park, the book takes an approximate anti clockwise direction around the two districts and concludes where it began at the park gates. Although it was not possible to cover every thoroughfare in Small Heath or Sparkbrook the two main shopping areas of the Coventry Road (the Cov) and Stratford Road have been included. Birmingham City FC (BCFC), St Andrews, has dominated one end of Small Heath since the turn of the twentieth century. Consequently the external structure of BCFC appeared in a number of the photographs of streets taken around the ground. The oldest and most historic part of both areas, 'The Farm' in Sparkbrook was photographed during the winter of 2009/10 and comparisons made with images from the past. Also images of the British Small Arms (BSA) the largest employer of labour from both districts have been included, images of the factory's greatness and of its decline. It was necessary to add some images of Deritend, Sparkhill and Balsall Heath to the book in order to provide continuity with borders that never existed (only on maps) to those who lived, work and socialised in and around Small Heath and (the brook) Sparkbrook.

Now for the first time, through the 180 sepia and full colour photographs displayed in *Small Heath and Sparkbrook Through Time*, comparisons can be made between what the two districts were like before and what they are like now. So for the reader who may only have known the now this book gives some idea of the past, and conversely those who lived or worked there and only knew the old this is a chance to reminisce about times gone by. To both it is hoped you enjoy the read and the look back.

Ted Rudge MA

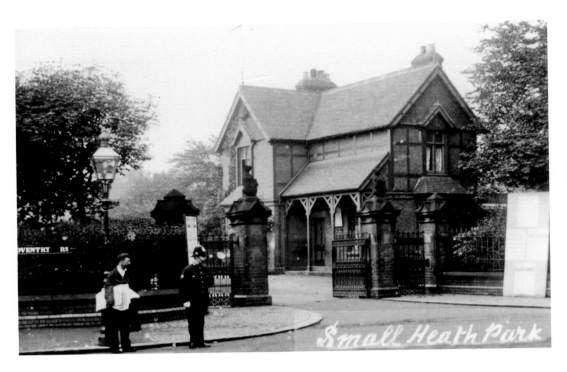

Small Heath Park Gates

Small Heath Park also known as Victoria Park was donated to Birmingham by Mrs. Louisa Ryland in the 1870s. This parkland is the largest green space in Small Heath with a large boating pool, bandstand and numerous mature trees within its forty-three acres. Immediately surrounded by Wordsworth, Waverley, Tennyson and Coventry Roads the latter containing the main entrance gates. When the policeman and the paper seller stood outside, the gate house was occupied and the gate pillars had small statues on but in 2010 they are gone and the house is boarded up.

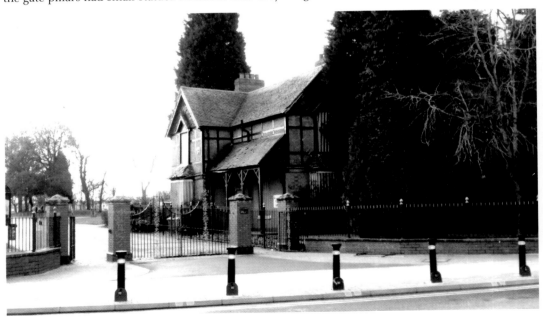

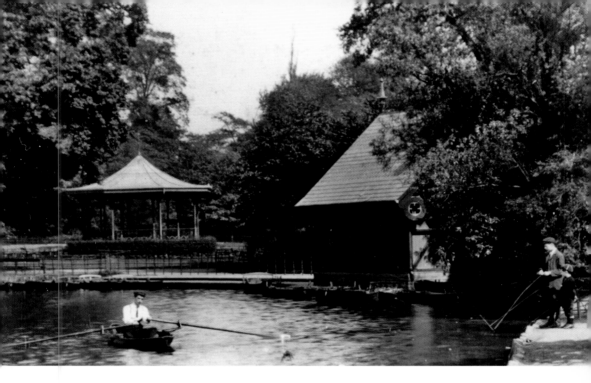

Boating Pool

A boathouse and bandstand has overlooked the boating pool in Small Heath Park since the Victorian period. Fishing and rowing appear to have been the main activities of the pool when the early photograph was taken, now it is home to a gathering of ducks and geese.

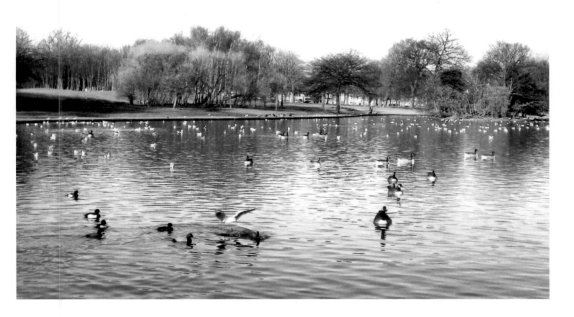

7

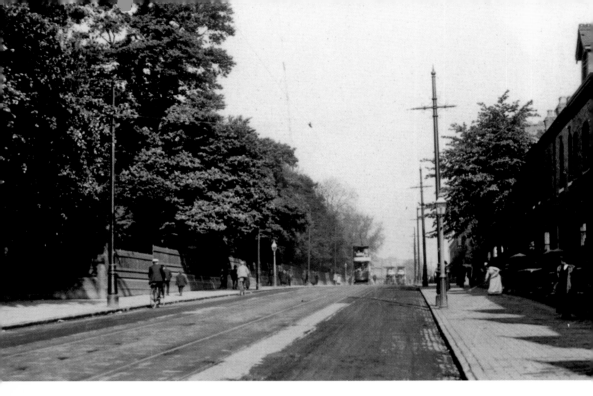

Coventry Road

Small Heath Park fronts this part of the Coventry Road displaying many mature trees. On the opposite side of the road apart from some houses having been converted into shop fronts and the tram no longer running up and down very little appears to have changed over the last century.

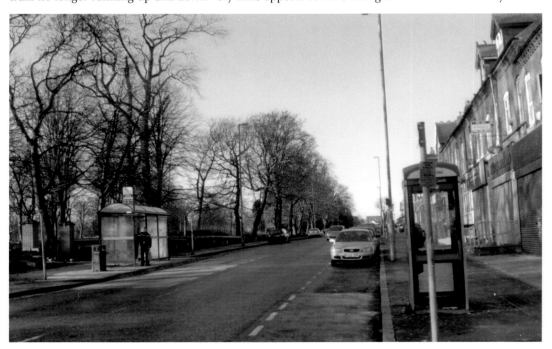

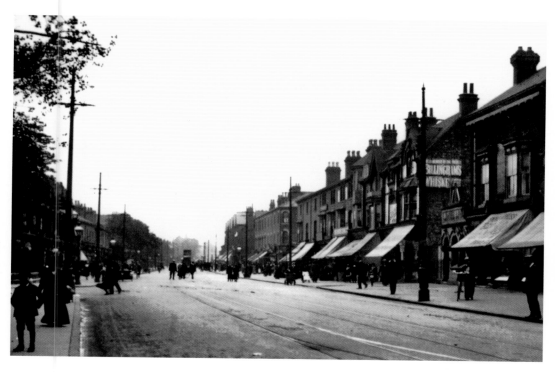

Coventry Road near Charles Road
This shopping area on the Coventry Road near Charles Road was built in the early 1900s when the shopper came by foot, bicycle or tram to do their shopping. Now in 2010 clearly the motor car and bus provide this function.

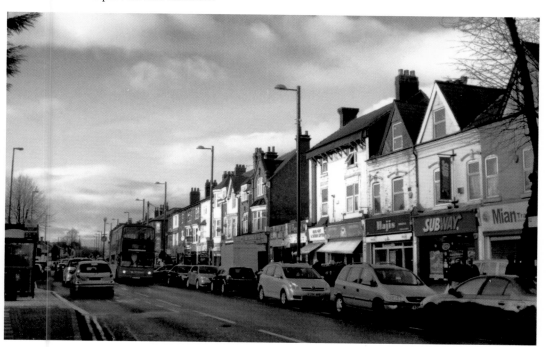

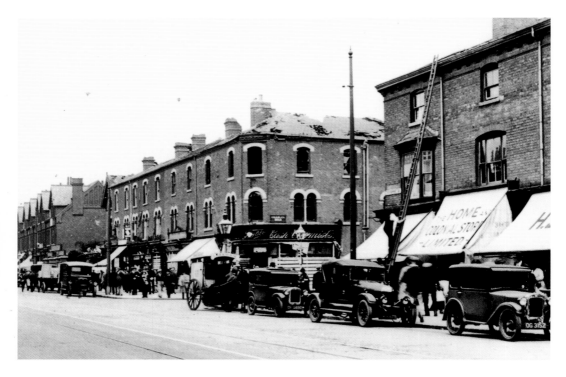

Charles Road Junction

Damage mainly to the roof and windows of certain shops was caused by a tornado that passed through this area on the 10 June 1931. Boots the chemist on the corner of Charles Road opposite Wordsworth Road had a large amount of damage to the roof. Working from a ladder on the other corner a workman pays no regard to modern health and safety standards.

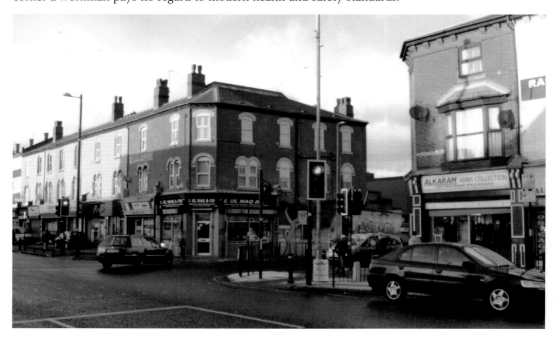

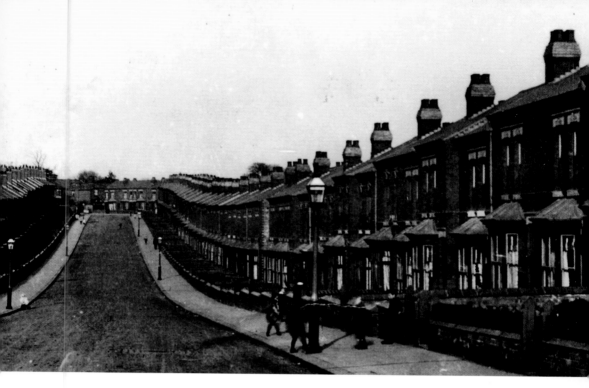

Bankes Road

Bankes Road viewed from St Benedicts Road shows a neat row of Victorian terrace houses built when motorised traffic was not a consideration. Environment a century later has turned the road into a large car park whereas the houses show little structural change.

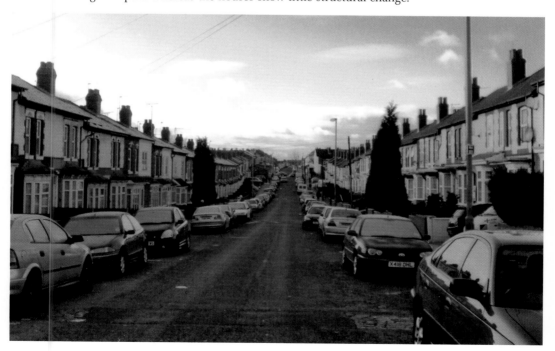

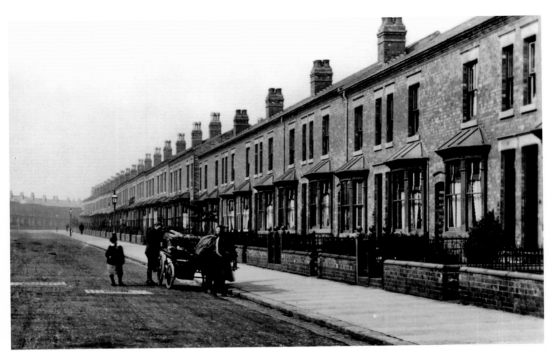

Somerville Road

Mature trees now line Somerville Road along from Heybarnes Road. No longer does the horse and cart visit this quiet road that has been overtaken by modern living and the transport of the twenty first century.

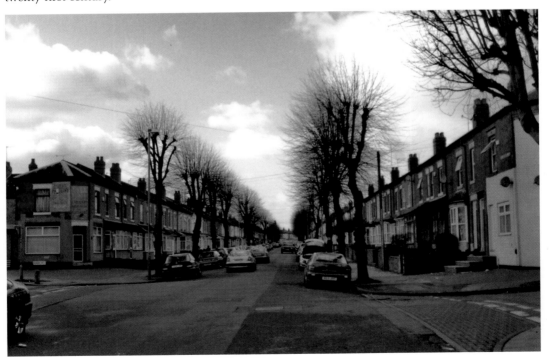

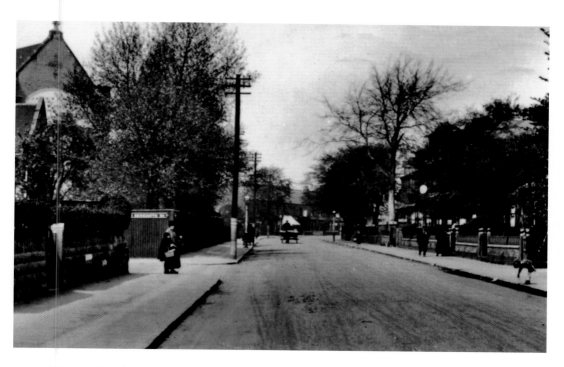

Hobmoor Road

Hobmoor Road where St Benedicts Road branches off to the left still has a church on this corner. Some architectural changes appear to have taken place just before the corner where the low garden wall and the privet hedge of the terraced housing has been replaced by modern flat roofed accommodation.

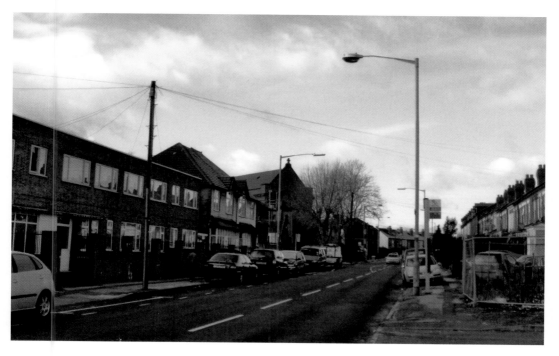

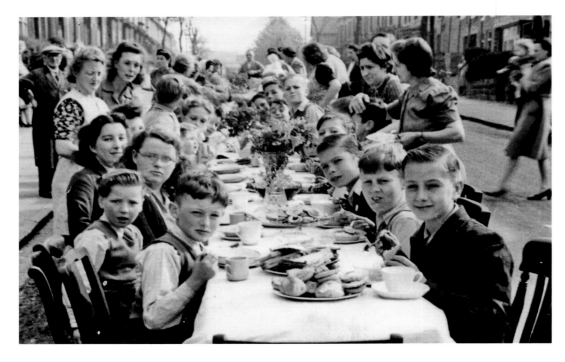

Kathleen Road (Hey Mills)

Road closures throughout England enabled street parties to be arranged to celebrate the Coronation of Queen Elizabeth II in 1953. Residents of Kathleen Road were photographed holding their party on tables erected in the middle of the road. A road that has seen little change since it was first built.

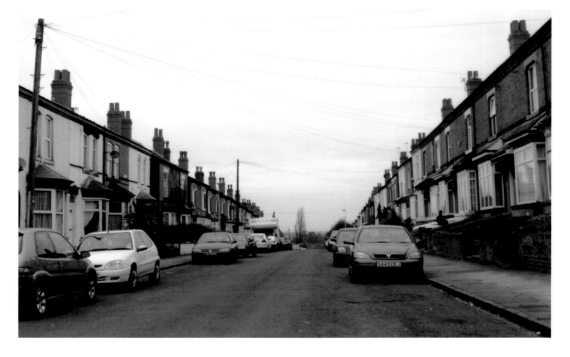

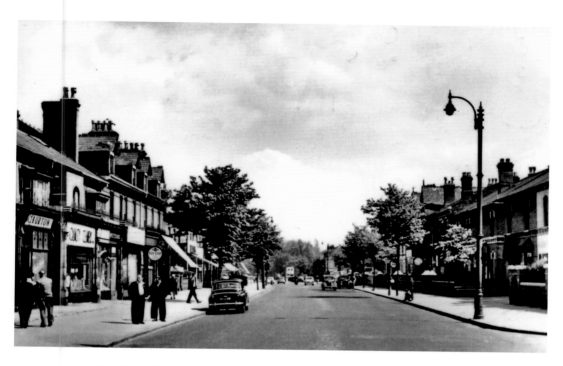

Coventry Road – Golden Hillock Road

Traffic lights now control the traffic at this normally busy T-junction. Front gardens have been removed from some properties on the right hand side of the Coventry Road easing the parking problems of the motor car but it's not the case on the opposite side where parking on the pavement alongside the shops is evident.

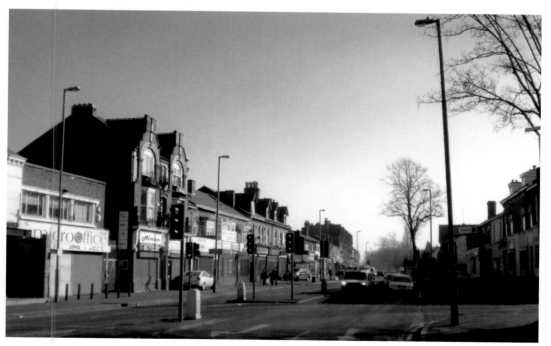

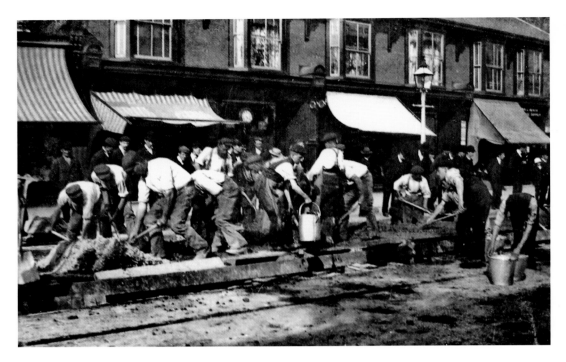

Laying the Tram Tracks

A smartly-dressed crowd has gathered to watch the laying of tram lines along the centre of the Coventry Road. In one photograph concrete foundations are being laid and in the other wooden blocks are being inserted between the rails. Later in another era after the blocks were no longer required they provided fuel for the open fires in local homes.

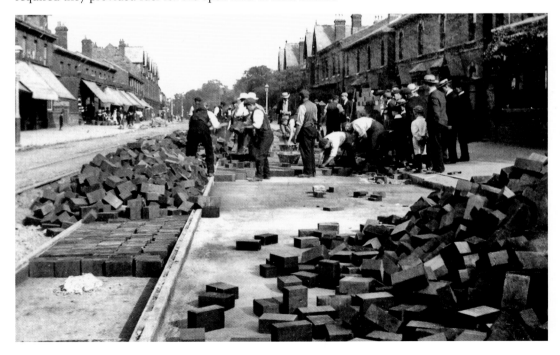

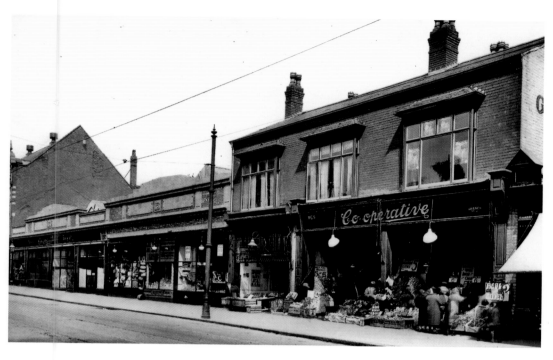

Coventry Road Co-op

Shoppers are seen queuing for bargains at the Birmingham Co-operative shops along the Coventry Road in the early photograph. The site in 2010 has been partially developed with new flat roofed shops and an open piece of land is used as a car park.

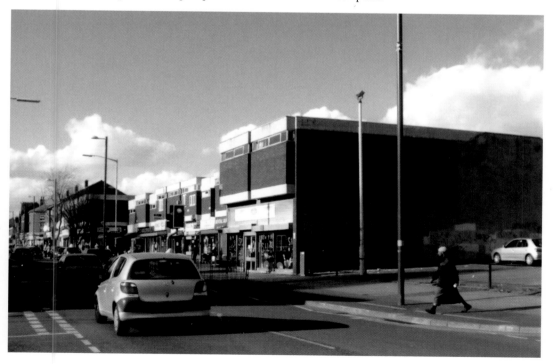

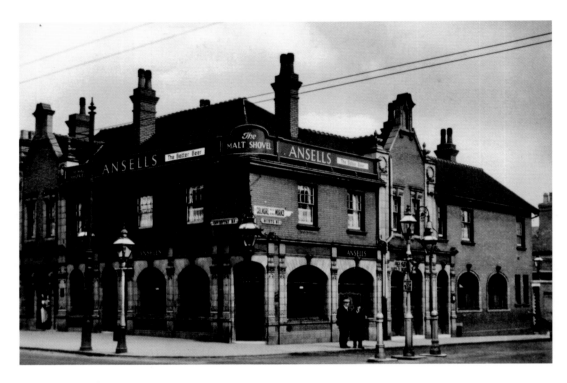

Coventry Road – Muntz Street

The Malt Shovel on the corner of Muntz Street and Coventry Road has retained most of its features over the years and now includes satellite dishes and a CCTV camera.

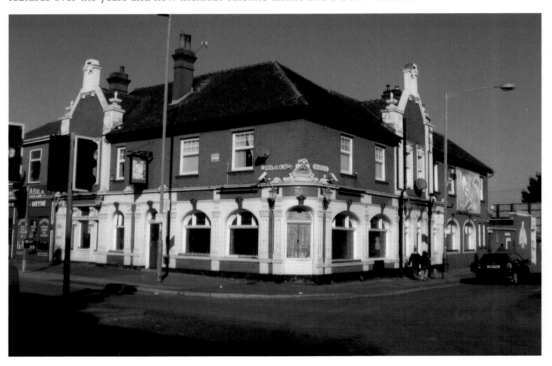

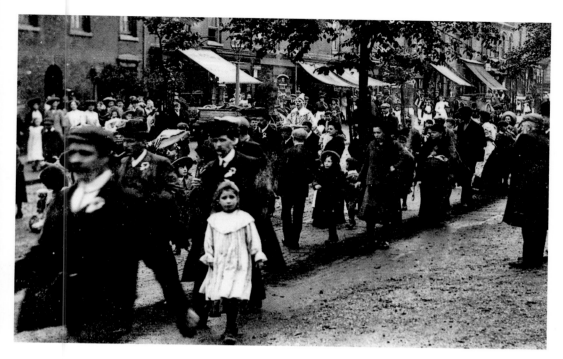

Crowds Gather

A photograph looking like a scene out of the Key Stone Cops with a charabanc filled with police was taken during the Prince of Wales's visit to Birmingham on 12 June 1923 near Golden Hillock Road. The other photograph may have been a Trade Union March as the men are wearing rosettes in this Coventry Road scene.

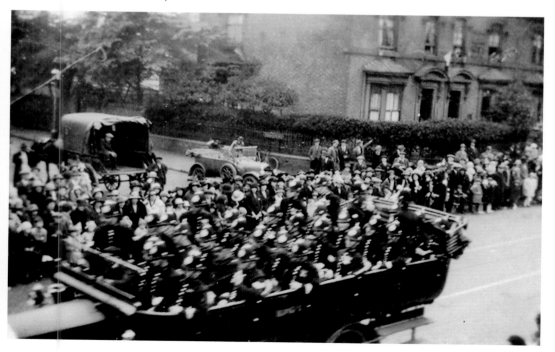

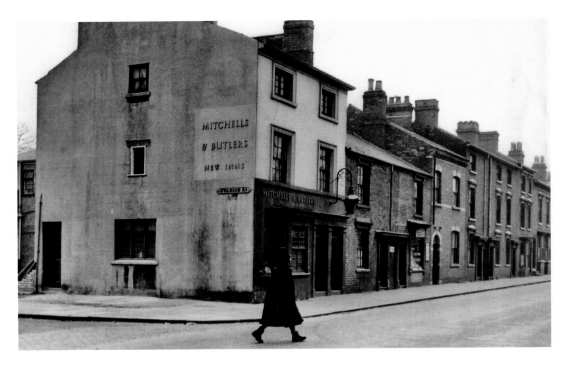

Muntz Street – Swanage Road

Back-to-back houses and the courtyards in Muntz Street have been demolished and the people that once frequented the New Inns public house have moved on. But with a change of name to 'The Nest' and a fried chicken shop as a neighbour, today's customers can watch satellite sport as they enjoy a different brand of drink than their predecessors.

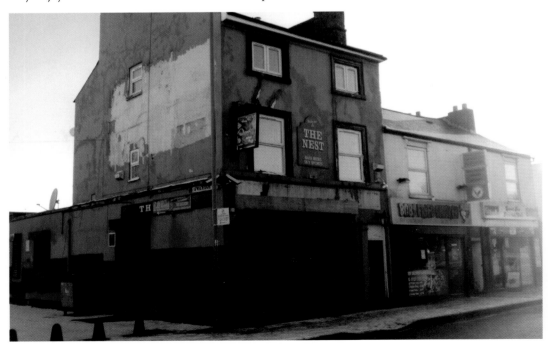

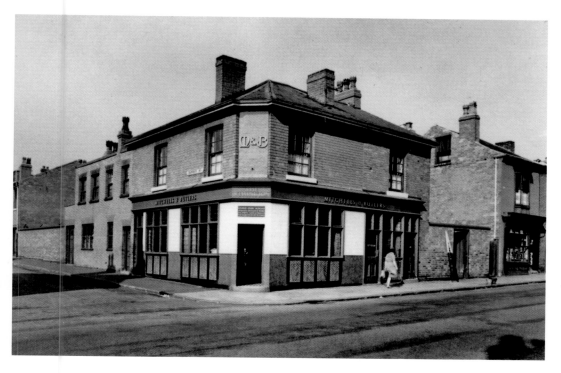

Muntz Street – Dawson Street

Located on the corner of Muntz Street and Dawson Street The Wellington public house finally closed its door in the mid 1950s. Demolition followed and no trace of the pub or the houses the customers lived in are visible today. These have been replaced by an enclosed sports facility.

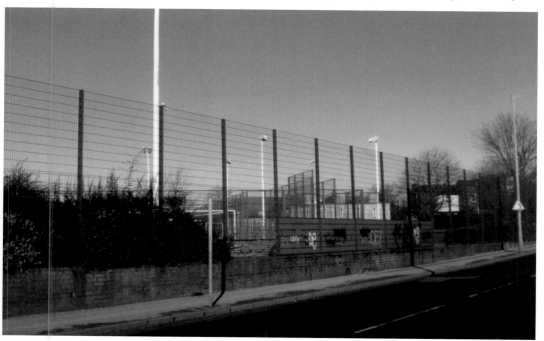

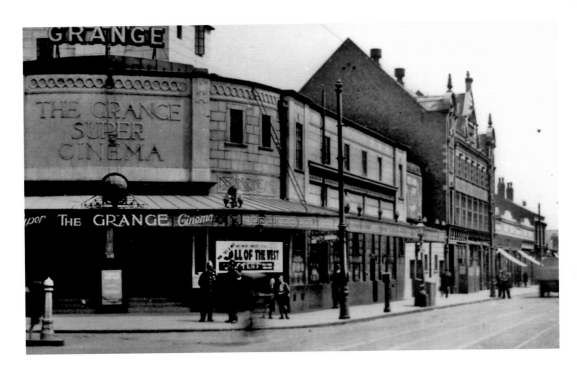

The Grange

A picture house (cinema) has occupied the corner of Grange Road and Coventry Road since 1915 when the 'Picture Palace' showing silent films opened. This was replaced in 1919 when 'The Grange Super Cinema' was newly built. The cinema finally closed its door in the late 1950s and now the site is occupied by the Sonali Bank.

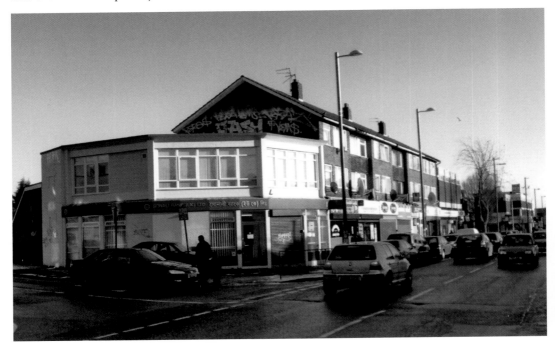

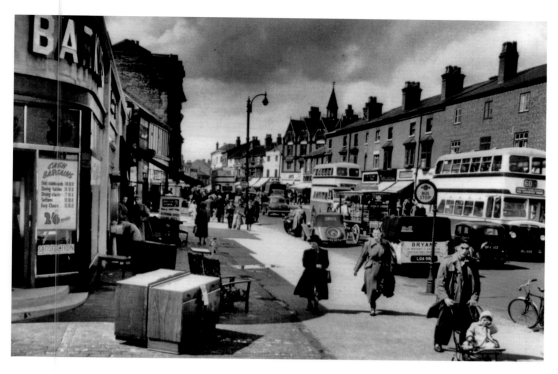

Coventry Road – Chapman Road

'The Cov' is a term local people used with reference to Coventry Road. 'Going shopping up the Cov' was a popular saying and would certainly have been used by the shoppers visiting this part of the Coventry Road where an array of busy shops still exists.

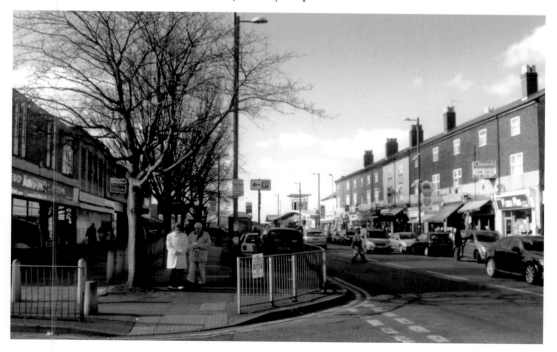

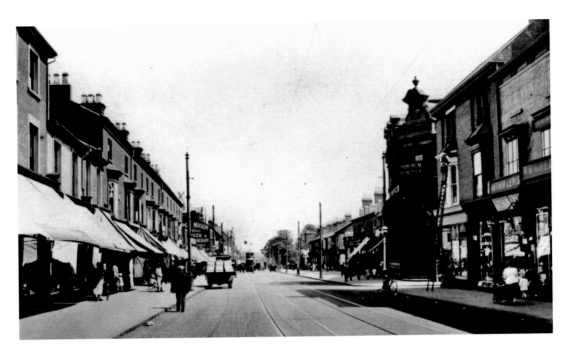

Coventry Road – Regent Park Road

Little change appears to have taken place to the structure of the properties on the left hand side of the Coventry Road at this point. George Mason the popular grocer was among the old shops but is no longer trading there on the modern photograph. On the right hand side Thomas Neal had his dental practice, above what looks like a bank, all the old properties have been replaced and trees newly planted.

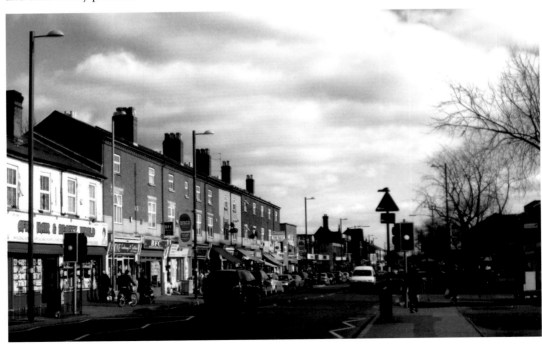

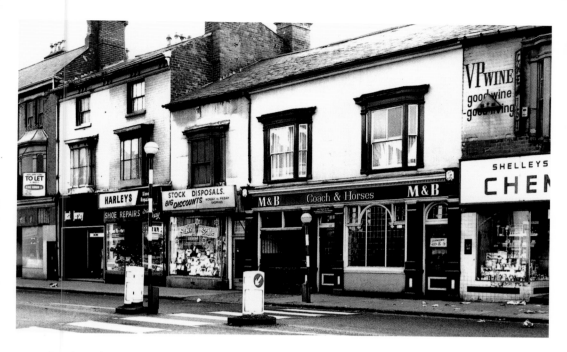

Coach and Horses

Modern shops and a car park on the Coventry Road opposite Green Lane in the early 1980s have replaced the row of shops that had the Coach and Horses public house among them. The name was probably a reference to the public transport at the turn of the century. In the far left corner of the pub is an opening big enough for a coach and horse to drive through to the courtyard behind.

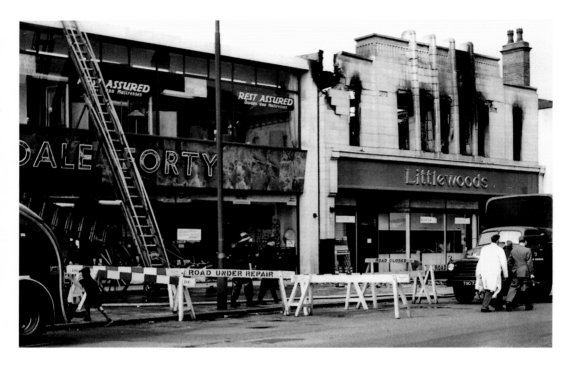

Littlewoods Fire

Dale Forty supplied furnishing from this shop on the Coventry Road next door to Littlewoods. Following a fire in 1980 the Littlewoods store got rebuilt and before it was eventually closed Hitchens catalogue store occupied the premises. Today both buildings are still located at this point having been equally altered to some extent.

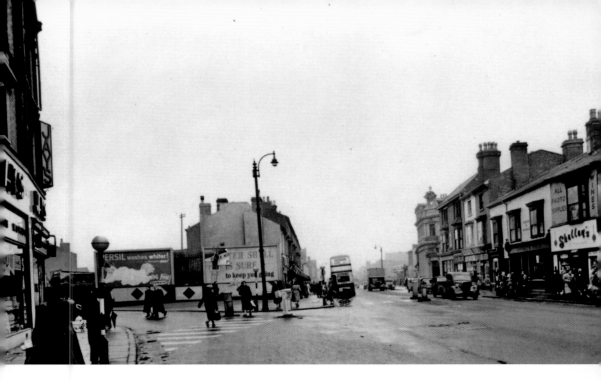

Green Lane Junction

Traffic heading away from the city along the Coventry Road still passes this junction at Green Lane where considerable changes have occurred to the buildings, but very little to the traffic flow.

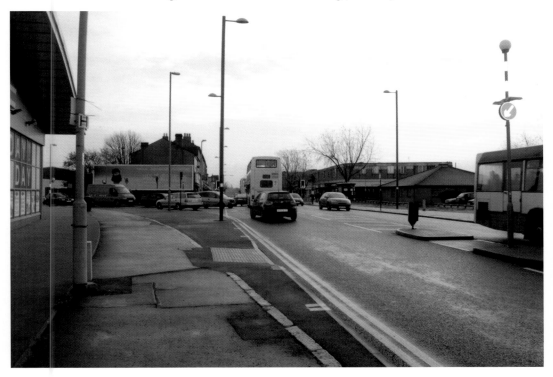

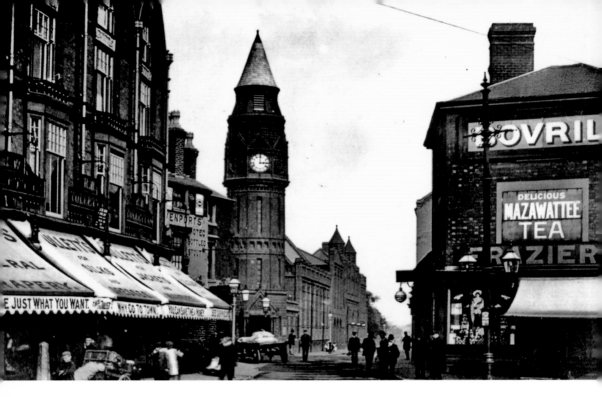

Green Lane – Little Green Lane

Little Green Lane is located directly off Green Lane having turned left on the Coventry Road. From the junction shops used to continue round the corner from Coventry Road but in 2010 an advertising board and a car park have taken the place of the shops.

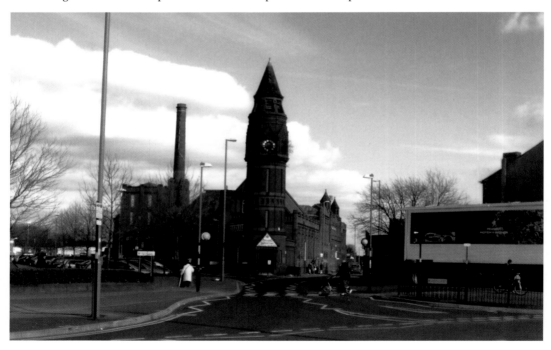

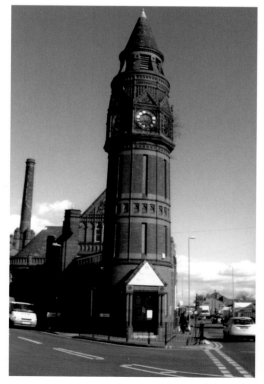

The Old Library
This Martin and Chamberlain red brick and terracotta building located on the junction of Green Lane and Little Green Lane first opened as a library in 1893. Four years later a swimming and washing baths was added, but in 1977 both the baths and library closed. Today the building is used by 'The Markazi Jamiat Ahl-e-Hadith UK' and is known locally as the Green Lane Mosque.

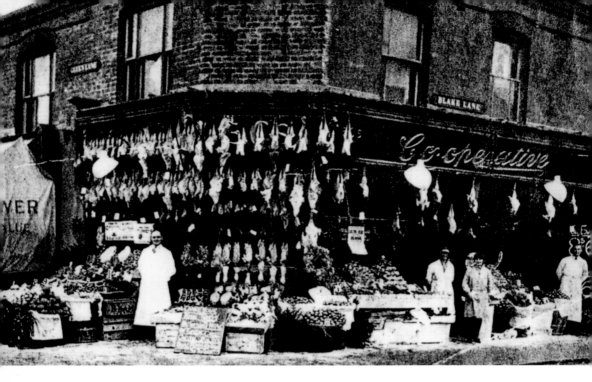

Green Lane – Blake Lane

Four shop assistants posing for a photograph outside a well-stocked Birmingham Co-operative green-grocery shop on the corner of Green Lane and Blake Lane. On the same corner in modern times the Co-op has been replaced by an electrical services business.

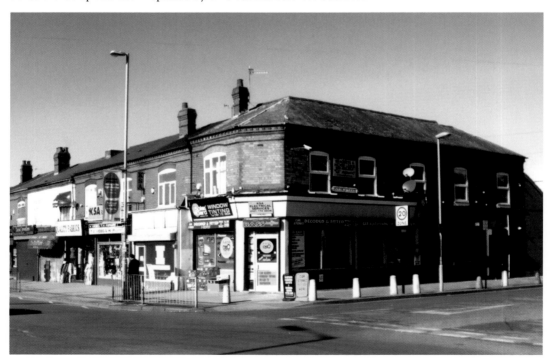

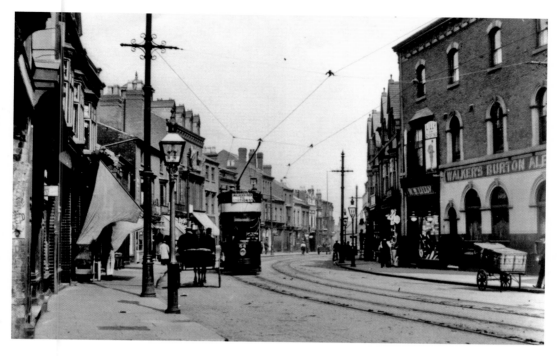

Coventry Road – Morrisons

Coventry Road in 1909. Note the two people travelling towards Birmingham in a horse and buggy having been overtaken by a tram. One hundred years later a Morrisons store dominates one side of the road and a mixture of flat roofed commercial organisations and houses occupy the other side of this usually very busy road.

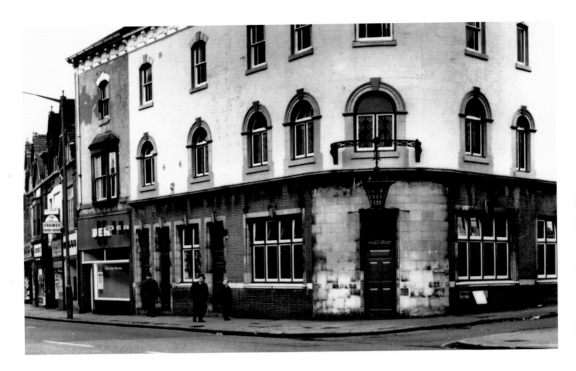

Bowling Green Road

The Wrexham public house on the corner of Coventry Road and Bowling Green Road was demolished together with a large number of shops to make way for the new Morrisons store. In the modern photograph Bowling Green Road has gone and The Wrexham is being demolished, covered in a green mesh as a precaution against falling masonry.

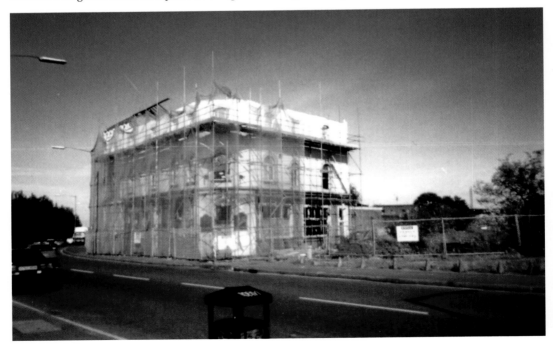

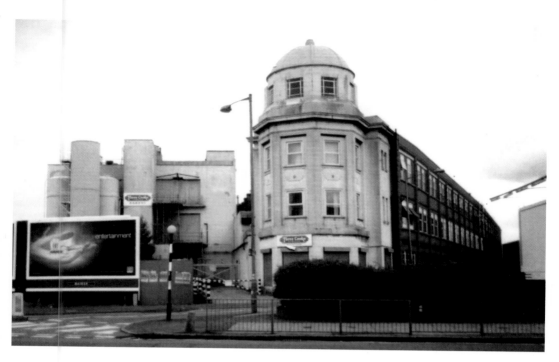

Wimbush Bakery

Just after the First World War the family-owned business of A. D. Wimbush opened their bakery in Little Green Lane shown here in 2000 just before it closed. No trace can be found of the bakery today following its demolition and the building of the new Morrisons store on the site of the old bakery.

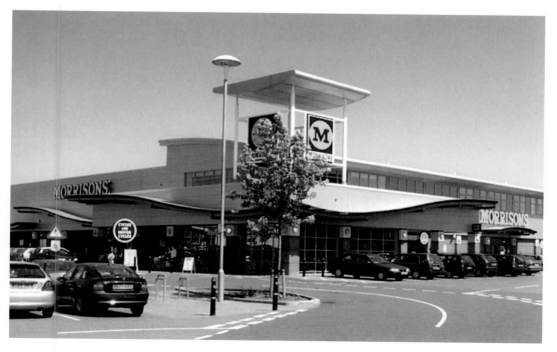

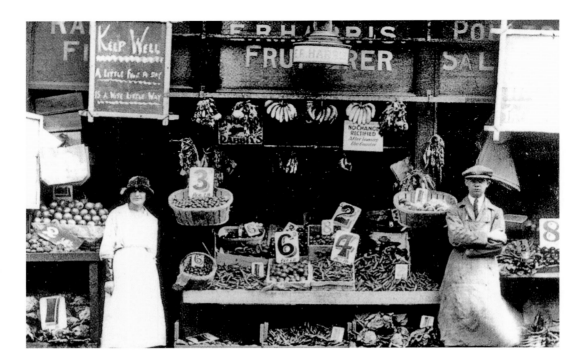

Harris's Shop Greenway Street

'Keep Well – a little fruit a day is a wise little way' displayed on a sign in 1928 alongside Harris's green-grocery shop is reminiscent of today's 'Eat five a day' government slogan to encourage healthy eating. One day when the circus came to Hay Mills they walked the animals along Coventry Road and an elephant picked up a cabbage from the shop with his trunk. Harris's shop at 230 Coventry Rd was next to the Oxford pub on the corner of Greenway Street. The site is now occupied by the Woolworths building that closed in 2009. St Andrews the home of Birmingham City FC in Cattell Road can also be seen in the background of the latest photograph.

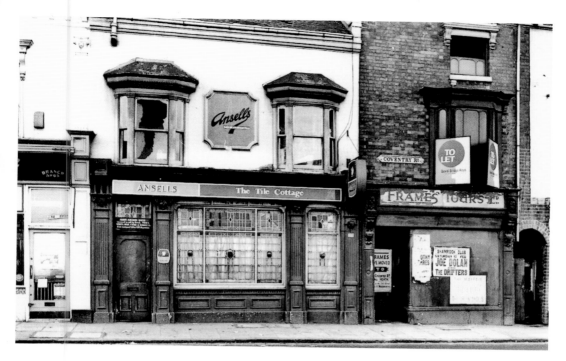

The Tile Cottage Coventry Road

Just two breweries, Mitchell & Butlers (M&B) and Ansells supplied most public houses in Birmingham before the 1970s. Typically where one pub was located another from the rival brewery could be found a short distance away. The Coach and Horses seen previously on page 25 could be found just a few yards away from The Tile Cottage that has now been replaced by modern housing.

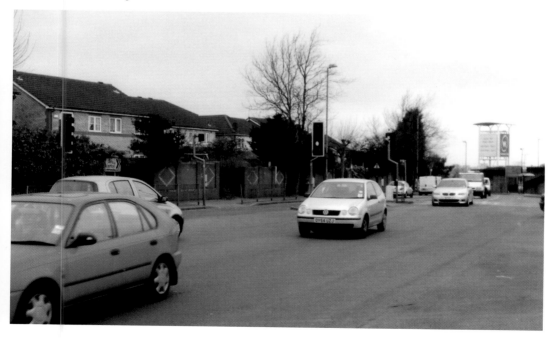

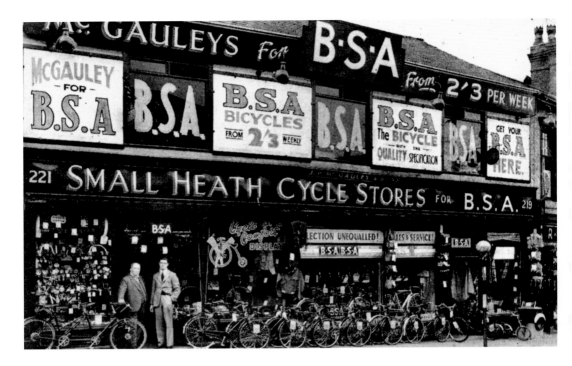

Mc Gauleys

Mc Gauleys Small Heath Cycle Store was located on the Coventry Road opposite Cattell Road junction. Advertisements displayed on the shop left nobody in any doubt what product they sold. British Small Arms (BSA) cycles appear to have been exclusively sold here even on hire purchase terms at two shillings and three pence a week (11.5p). Now wall fronted modern homes have been erected where Mc Gauleys once traded with a view of the Birmingham skyline in the distance.

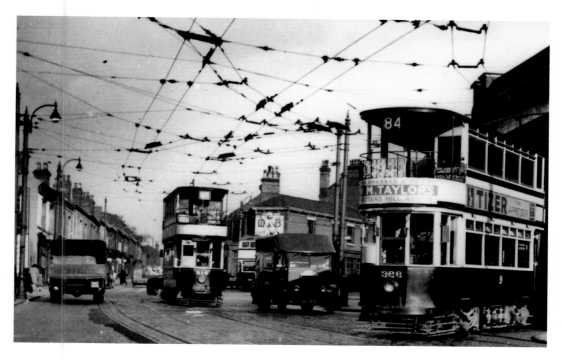

Small Heath Tram Depot

The line of Coventry Road dog legs at the point where the Small Heath Tram Depot is situated in the early photograph opposite the busy Cattell Road junction. Following the closure of the tram/bus depot and the demolition of the Victorian back-to-back houses in Cattell Road Woolworths acquired a new building and Birmingham City FC became visible from the junction.

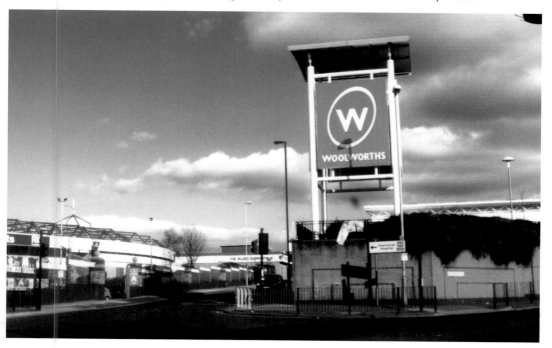

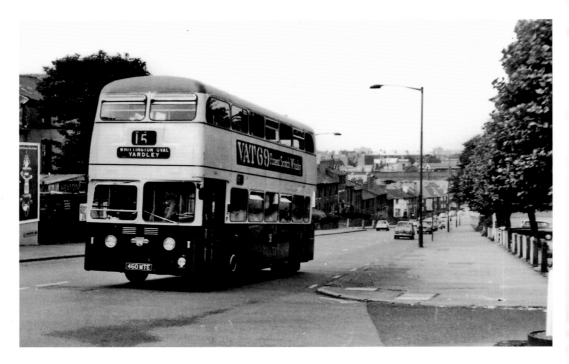

The Kingston

A number 15 bus travelling towards Yardley away from the city centre along the Coventry Road was just passing the Kingston cinema behind the trees on the left. Opening in August 1935 the cinema later became the Essoldo Bingo and Social Club before it was demolished and the site developed as a coach/car park for Birmingham City FC.

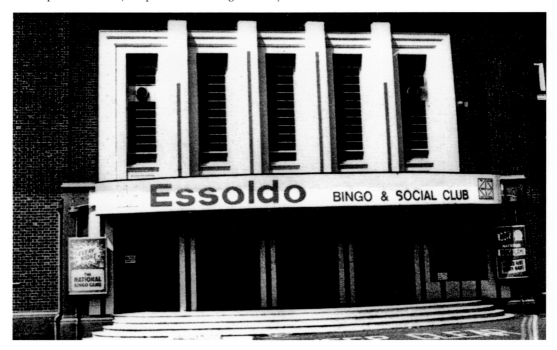

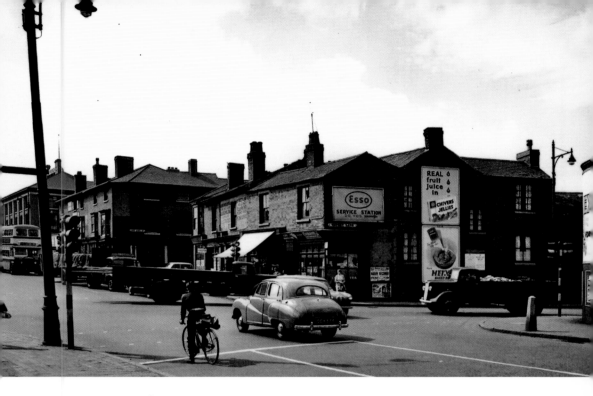

Watery Lane Junction

Traffic lights control the flow of traffic at the Coventry Road, Sandy Lane and Watery Lane Junction in 1956. Progress has brought a large traffic interchange island to this spot with the Small Heath by-pass added to the original list of roads.

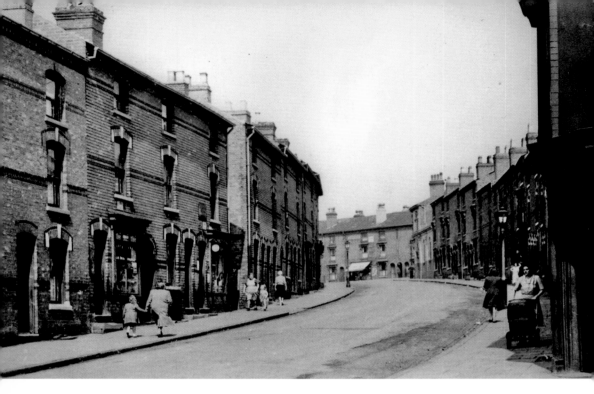

Bordesley Park Road – Arthur Street
Clearance of the old houses that were built at the beginning of the twentieth century has brought a new road layout to this area, in the new photograph the view is of Bolton Road having been rebuilt where Bordesley Park Road once was, with Arthur Street at the far end.

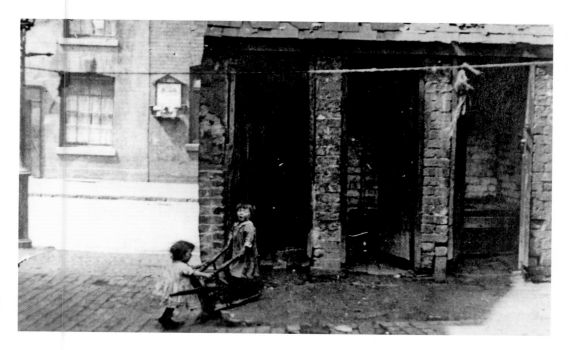

Arthur Street

Arthur Street in 2010 with its high rise flats and modern houses, one with mock Doric pillars, bears no resemblance to Arthur Street in the early photograph. Two children play with a wooden chair near to the brick built outdoor lavatories that were shared by the families who lived in the back-to-back housing. Across the road, fixed to the wall, is a memorial to the men from the street that died in the First World War.

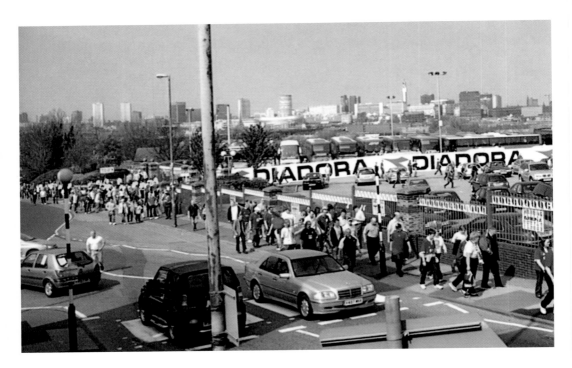

Match Day at the Blues

St Andrews, built on the site of a former clay pit on Cattell Road has been the home of Birmingham City FC since 1906. Before moving to Cattell Road the club founded in 1875 as the Small Heath Alliance FC played their home fixtures at their Muntz Street ground. Spectators in the 2010 photograph are seen walking up the incline towards St Andrews on match day with the skyline of Birmingham city centre behind them.

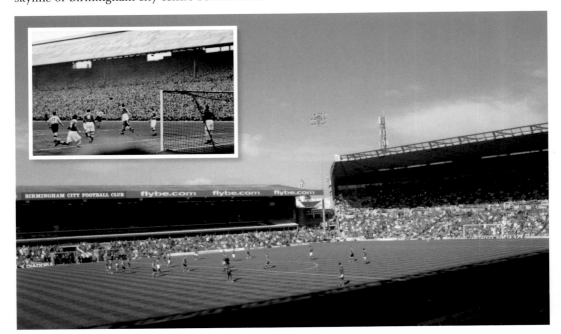

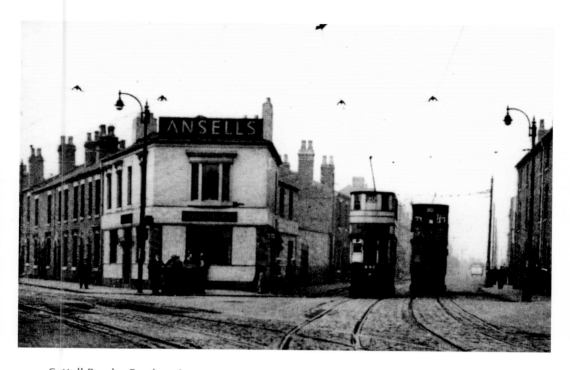

Cattell Road – Garrison Lane

On the border of Small Heath and Bordesley Green in 1948 another public house The Atlas fronts the corner of Cattell Road and Garrison Lane road junction. Following the removal of the trams, tram lines, the houses and The Atlas this junction in 2008 has taken on a very open aspect.

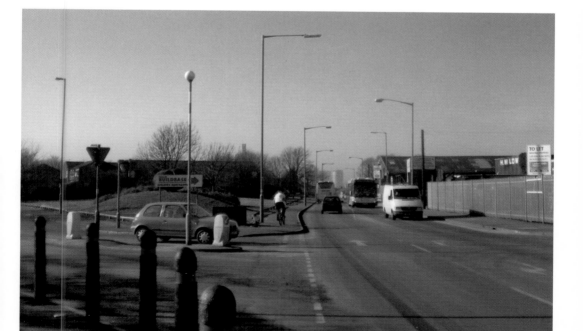

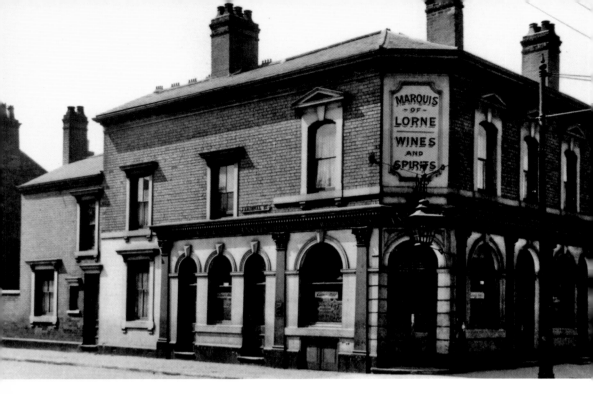

Arsenal Street

Marquis of Lorne public house renamed The Roost still stands on the corner of Arsenal Street and Cattell Road having survived the demolition of the working class housing that its customers used to live in.

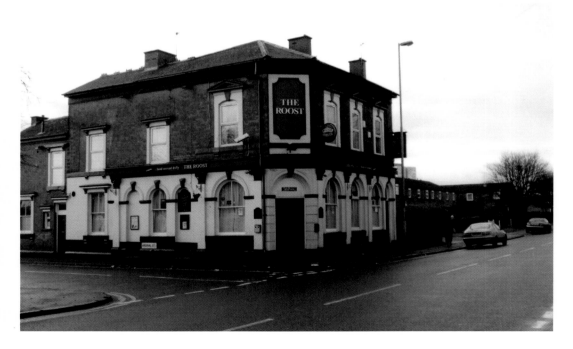

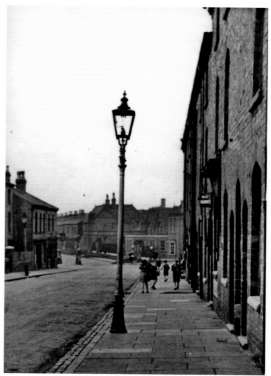

Tilton Road

In the early photograph children are seen playing in Tilton Road with the school building behind them at the far end. Tilton Road School is a Grade II listed building originally built as a boarding school in 1890. Currently the building is the home of the Darul Barakaat Mosque and Community Centre.

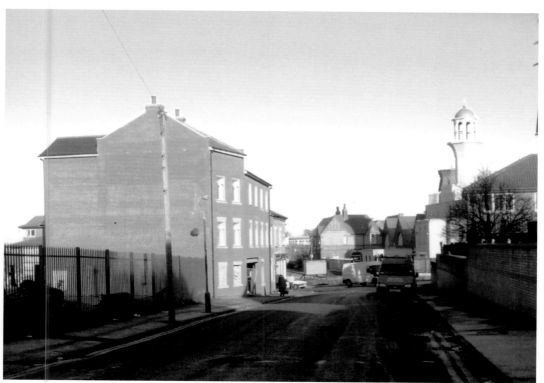

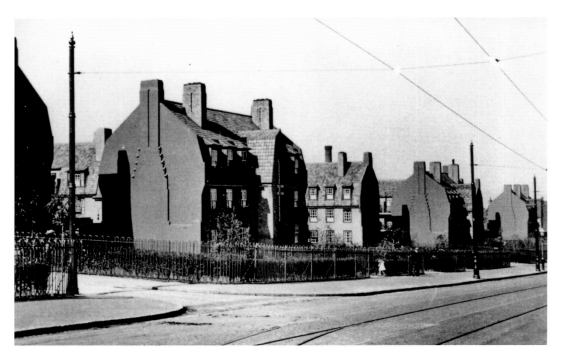

Dutch Flats

Built in 1927 still standing and lived in today are the first municipal flats built in a Dutch style by Birmingham Corporation in Garrison Lane. Although Garrison Lane has altered from a rather congested thoroughfare into a modern dual carriageway the flats remain the same, apart from the addition of satellite dishes.

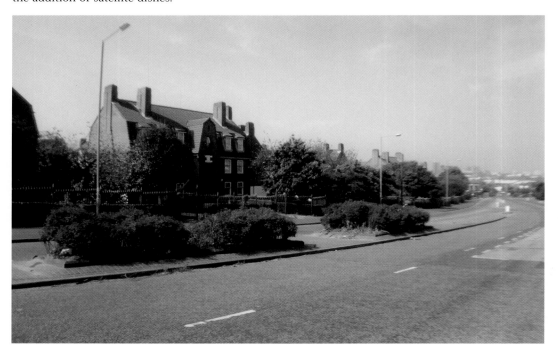

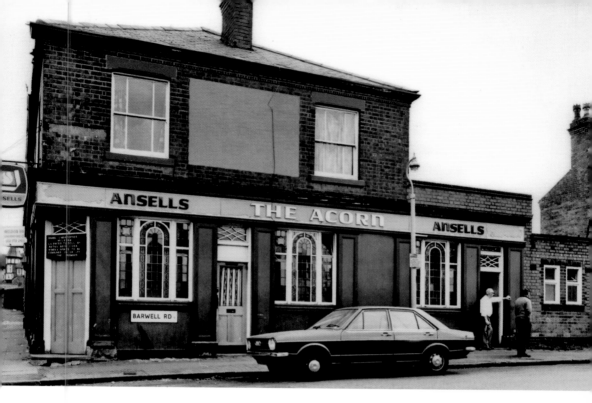

Barwell Road

One corner of a stand from Birmingham City FC can be seen behind the new houses that replaced The Acorn public house on Barwell Road.

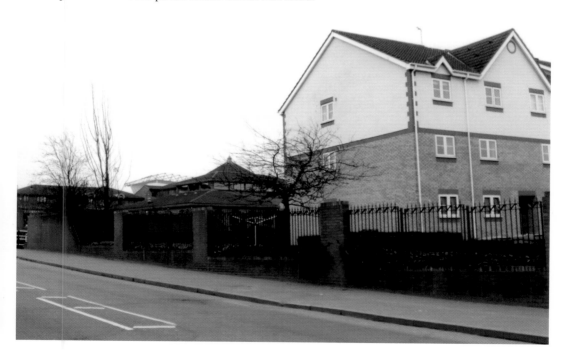

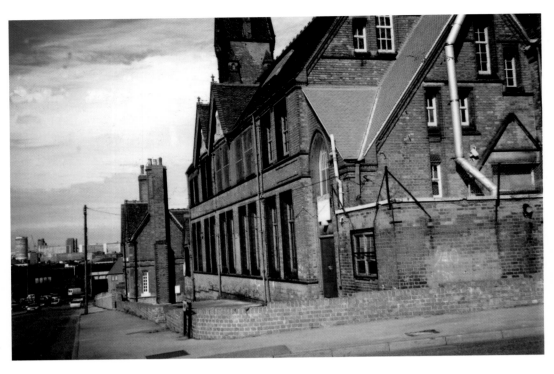

Dixon Road School
This Grade II red brick listed Martin and Chamberlain building was built on the corner of Dixon Road and Cooksey Road between 1880 and 1890. Although it was first built as a boarding school to educate the local children it no longer does so today.

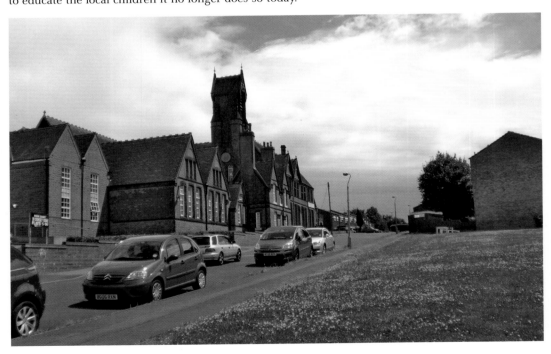

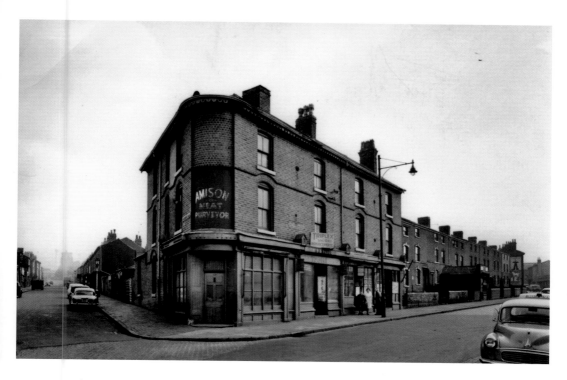

St Andrews Road
Substantial terraced houses with gardens fronted this part of Watery Road in the 1960s with a small row of shops before the corner with St Andrews Road, where houses not so generous in size could be found. In 2010 most of this location has been built over with a large garage and petrol station and renamed Watery Lane Middleway. Birmingham City FC ground can now be seen at the end of St Andrews Road following the removal of the houses.

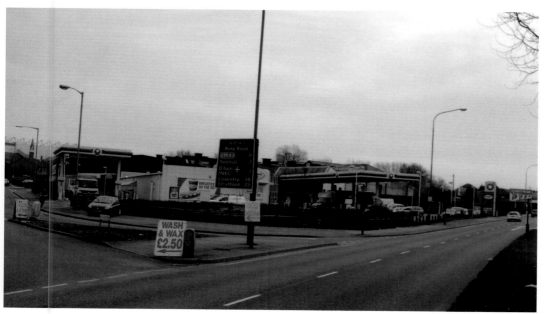

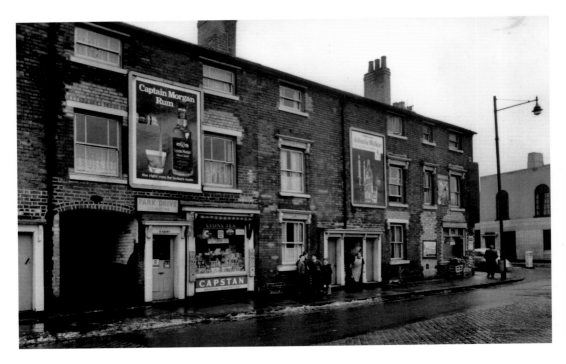

Watery Lane

Back-to-back houses together with two small shops, one with an opening at the side, which probably led to stables at the rear in another period existed in Watery Lane at the corner with Kingston Road in the 1960s. Replaced brickwork around the windows and doors are an indication of the poor condition the properties were in prior to demolition. Now this part of Watery Lane Middleway has been fenced off with shrub land behind.

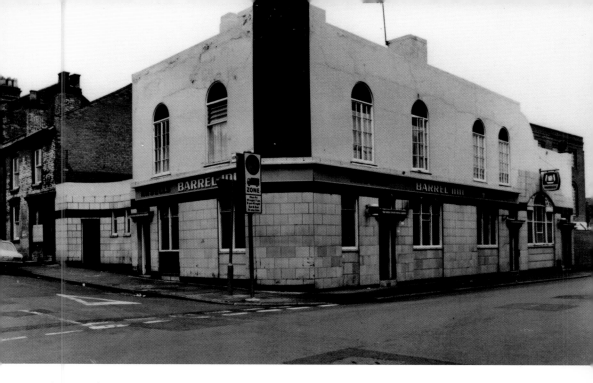

The Barrel Inn

Ansells white-tiled Barrel Inn on the corner of Watery Lane and the working class housing on Kingston Road has given way to the building of an up market Audi car show room with a telephone exchange behind.

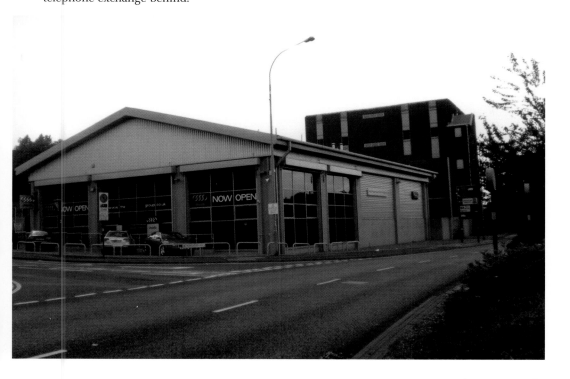

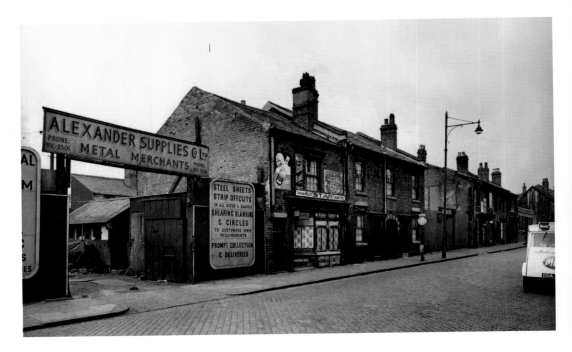

Contrasting Watery Lane

A factory, shops and back-to-back houses all existed side by side along the short stretch of Watery Lane in the early photograph. Today all this has disappeared under redevelopment and has been replaced by modern industrial units set in a green landscape environment that contrasts greatly from what was there before.

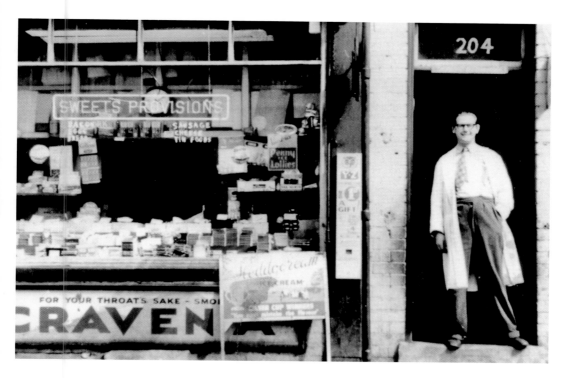

Keegan's Shop – St Andrews Road
Mr Keegan seen here standing on the doorstep of his shop at 204 St Andrews Road in the 1960s.
Following the demolition of the old housing and shops in this road a number of new modern
homes were built overlooked by Birmingham City FC and St Andrews School steeple.

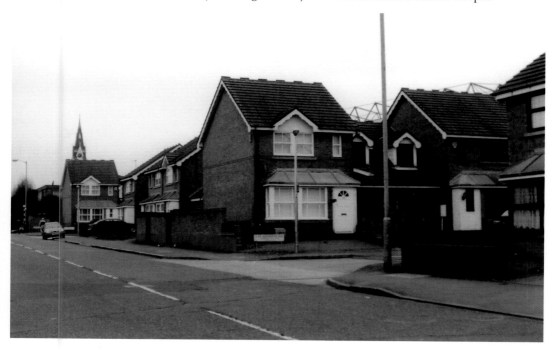

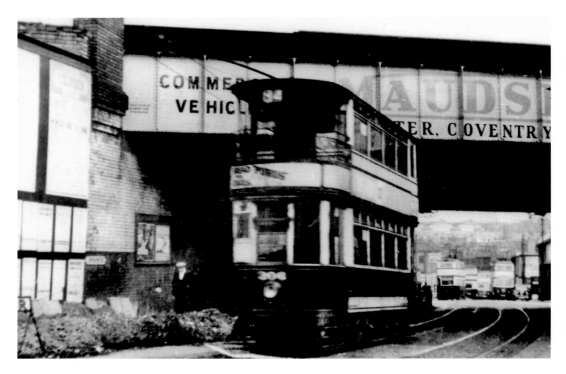

Public Transport

Three aspects of public transport are shown in the early photograph. Several buses in the distance and the number 84 tram travelling towards Bordesley Green are seen passing under the railway bridge at the Camp Hill end of the Coventry Road. Use has been made of the brick arch supports either side of the bridge where numbered lock up units now exist.

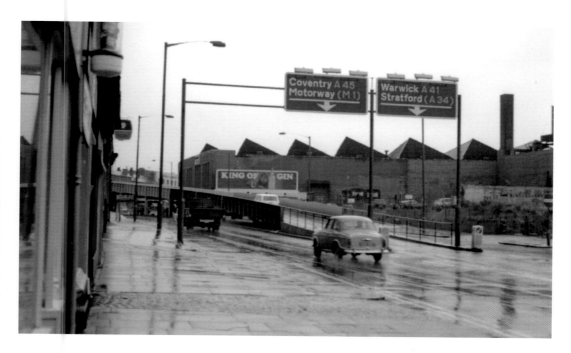

Camp Hill Flyover (Bordesley)

Camp Hill Flyover was constructed in the 1960s as a temporary solution to a traffic problem where the Coventry Road meets Camp Hill. Traffic travelling to and from Birmingham city centre drove over the steel structure whereas traffic coming in and out of the Coventry Road drove under the flyover. It was so successful that the temporary solution extended until the 1980s when it was dismantled. On Sunday 14 March 2010 the Birmingham St Patrick's parade marched along Camp Hill towards the city centre.

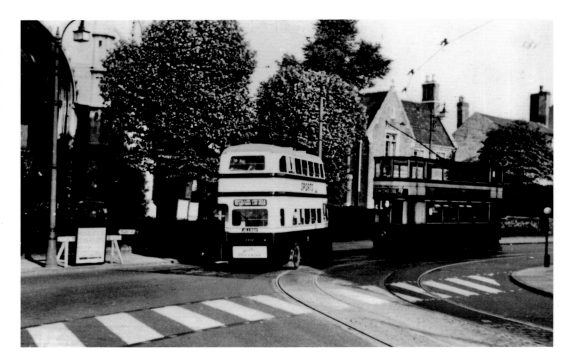

Holy Trinity Church (Bordesley)

A tram in 1953 is heading towards Birmingham city centre and in each photograph a bus is travelling out of Bradford Street into Camp Hill passing the Holy Trinity Church building *en route* to Sparkbrook. The church was designed by Francis Goodwin and Church of England services were held there from 1823 until the 1970s when it closed. Temporary uses of the building as a hostel for the homeless and other functions have taken place since the official closure.

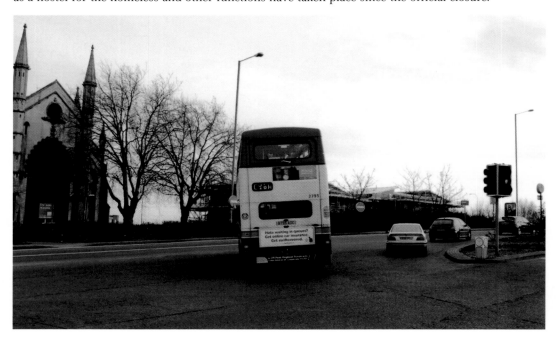

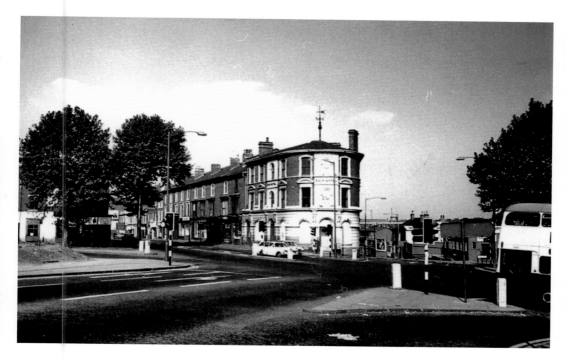

Camp Hill – Stratford Place

The name Camp Hill has derived according to local belief from Easter Monday 3rd April 1643 when the army of Prince Rupert, nephew of King Charles camped there before fighting their way through to Birmingham the next day. It is also believed that the prince used the Old Ship Inn (now demolished) on Camp Hill as his headquarters overnight. One surviving building from that period Stratford House a Grade II* listed building dating from 1601 can be found in Stratford Place off Camp Hill Island.

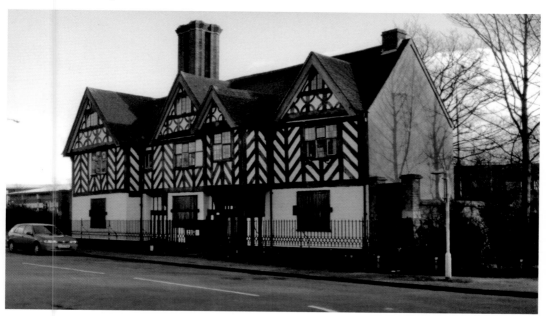

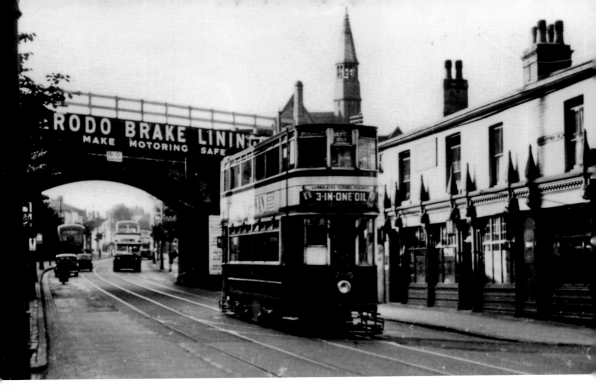

Stratford Road – Henley Street

Stratford Road begins after Camp Hill just beyond the railway bridge where the tram in 1953 has just passed under. A public house bearing the name The Shakespeare still serves drinks from the corner premises of Henley Street.

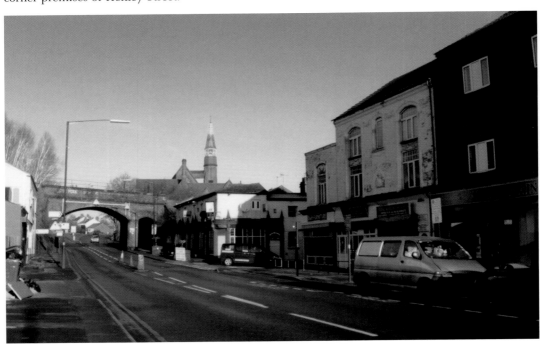

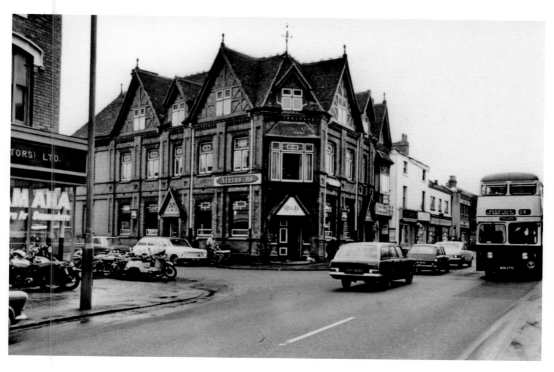

Kyotts Lake Road

Built in the 1880s an impressive building stands out among the shops on the corner of Stratford Road and Kyotts Lake Road once home of the Black Horse public house. Today following a change of use oriental food is served from a restaurant on the ground floor.

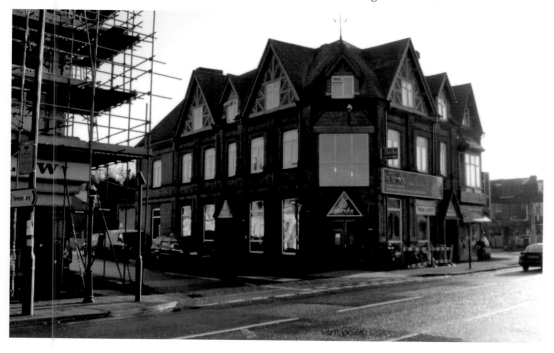

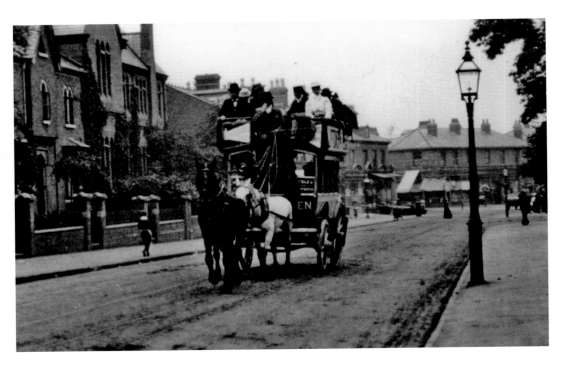

Stratford Road – Farm Road

Sitting on the top of a coach drawn by horses passengers using public transport along the Stratford Road in 1912 were open to the elements. A number six bus on the same route passing Farm Road in 2010 affords much more comfort to the travelling public.

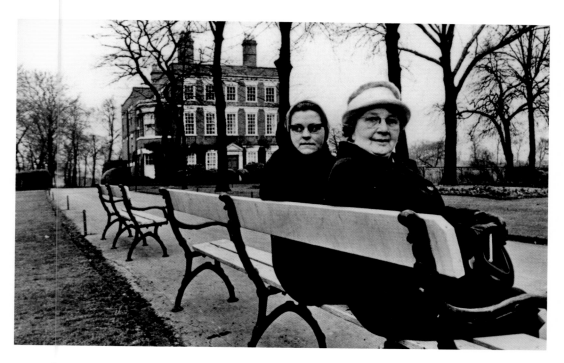

The Farm

Displayed on the house behind the two ladies sitting on the bench is an English Heritage blue plaque. The inscription reads 'Sampson Lloyd 1699-1779 founder of Lloyds Bank lived here'. He had this Georgian house built, now a Grade II* listed building, on land he bought in 1742 called 'The Farm' in Sparkbrook. Today this green open space is a reminder of the rural past and provides Sparkbrook with a much needed open space.

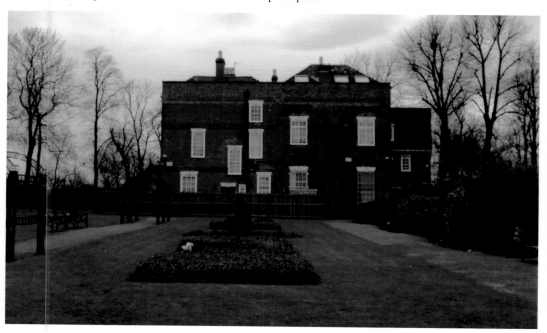

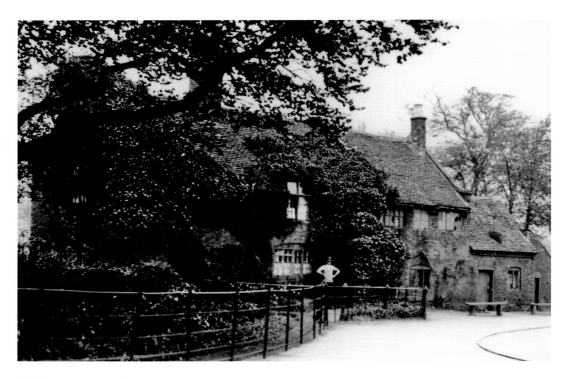

Old Cottage at the Farm

No trace of the cottage shown in the old photograph exists today. It was originally built on 'The Farm' land near the Georgian house but was demolished sometime in the twentieth century and the land returned to grass. An elderly gentleman walking his dog on the day the new photograph was taken could remember where the cottage once stood.

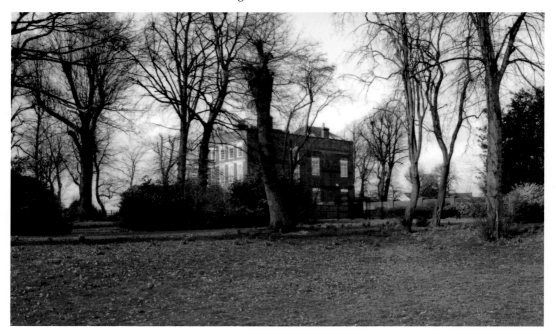

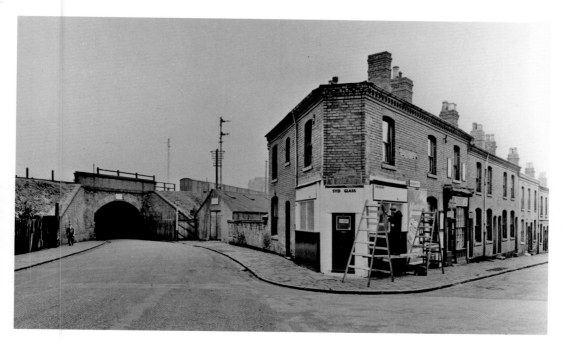

Kyrwicks Lane

Auckland Road branches off Kyrwicks Lane where the premises of Syd Glass is being decorated. Next to Syd's is another back street shop where the local people living in the back-to-back houses were able to obtain groceries. Kyrwicks Lane continues under the railway bridge towards Camp Hill in both images but the Auckland Road corner is now occupied by a 'Train to Gain' business and trees obscure the railway behind.

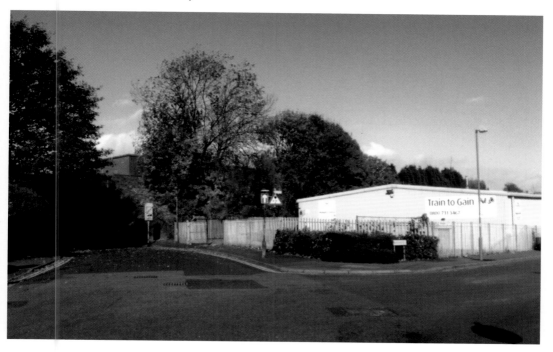

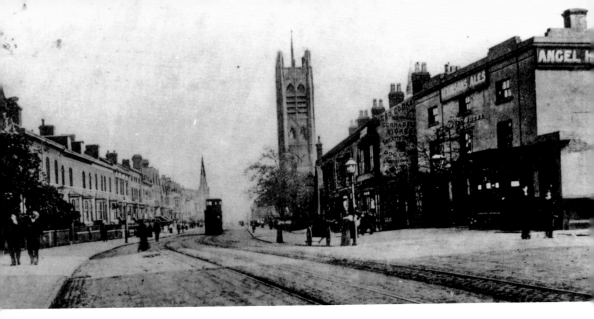

The Angel Hotel

Two outstanding landmarks on the Stratford Road, Sparkbrook are the Angel Hotel and St Agatha's, a Grade I listed church designed by W. H. Bidlake and built between 1899 and 1901. Both are shown on the postcard dated 15 February 1904 and the modern photograph taken in January 2010.

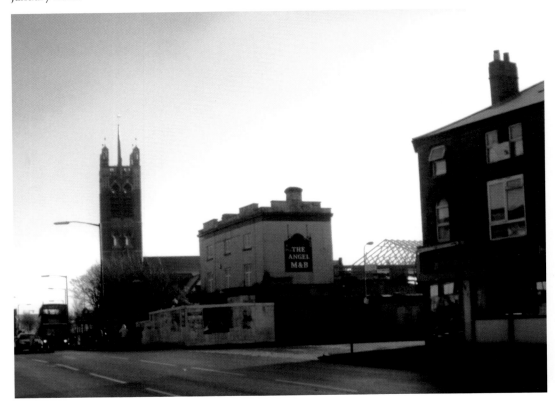

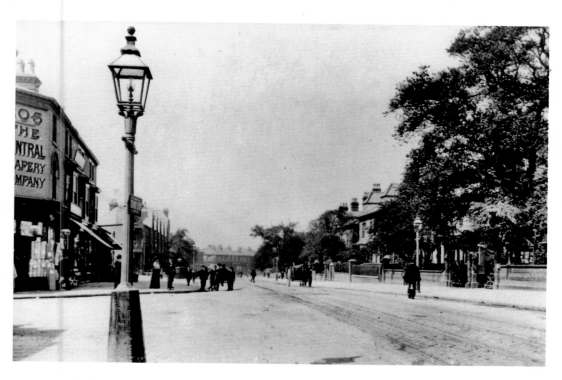

Stratford Road – Ladypool Road
Stratford Road towards the city in the early 1900s. Ladypool Road and Main Street on the left appear to be unaltered after over one hundred years have passed.

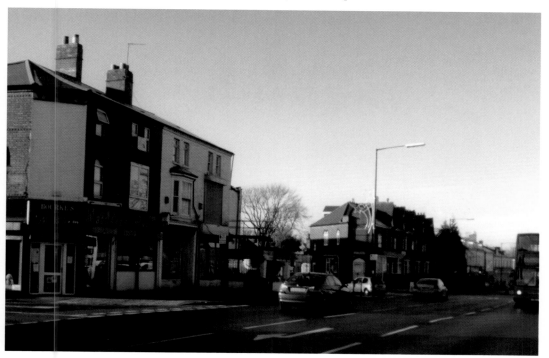

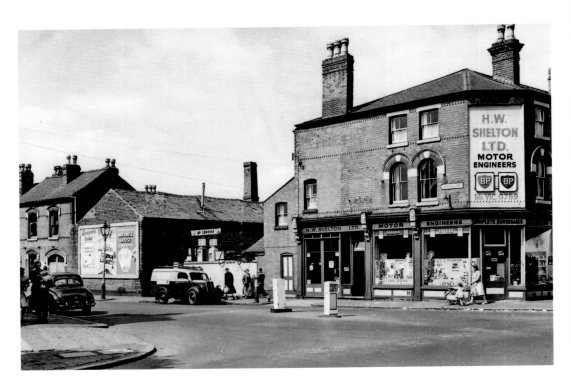

Ladypool Road Motor Engineers

H. W. Shelton motor engineers occupied the premises on the corner of Stratford Road and Ladypool Road in the 1950s and sold BP petrol from pumps situated above a wall at the rear. A general grocery store now trades from this virtually unaltered building.

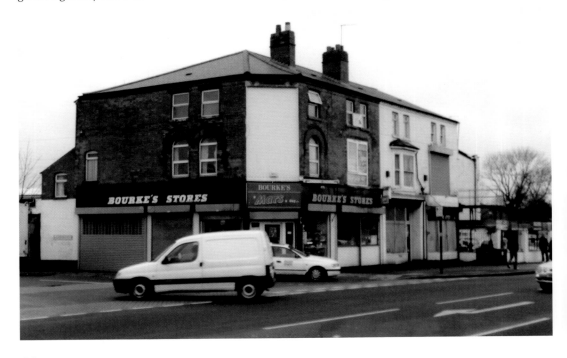

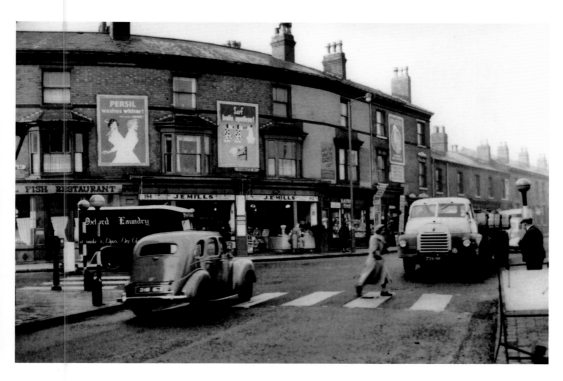

Ladypool Road – Highgate Road

A green open space now exists where the shops and houses in the 1950s photograph once stood at the busy crossroads of Ladypool and Highgate Roads.

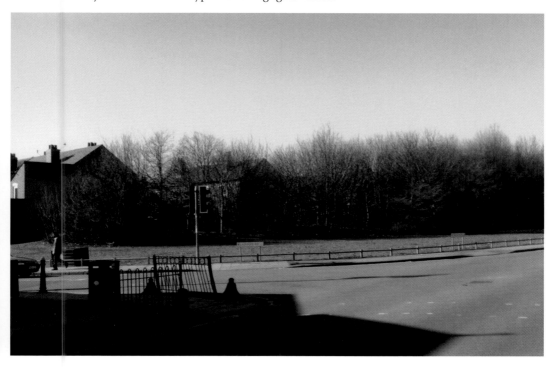

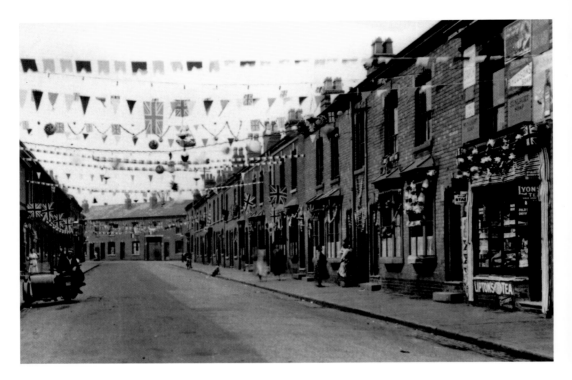

Tillingham Street

The flags came out in May 1937 when the residents of Tillingham Street that ran from Ladypool Road to Turner Street celebrated the coronation of King George VI. Turner Street can be seen crossing at the far end in the early photograph but following the demolition of the back-to-back properties in the 1960s Tillingham Street disappeared and Turner Street was realigned with a green area among the new houses.

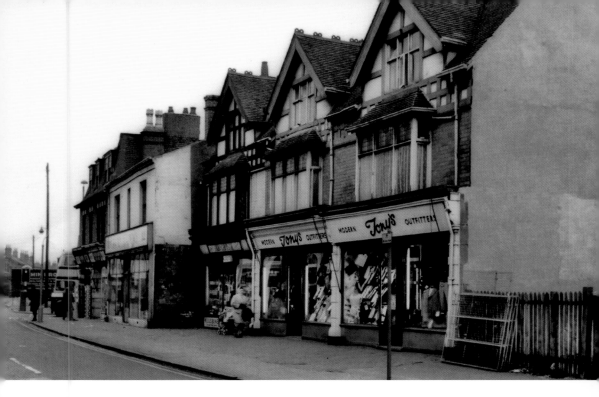

Ladypool Road Shops

Highgate Road and Ladypool Road cross at the end of this row of shops. Between the 1960s and the 2010 photograph considerable changes have been made to the roofs of the various shops.

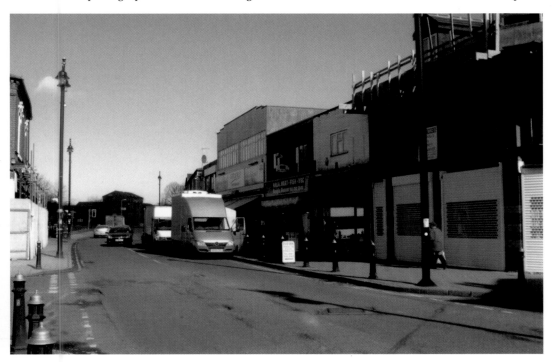

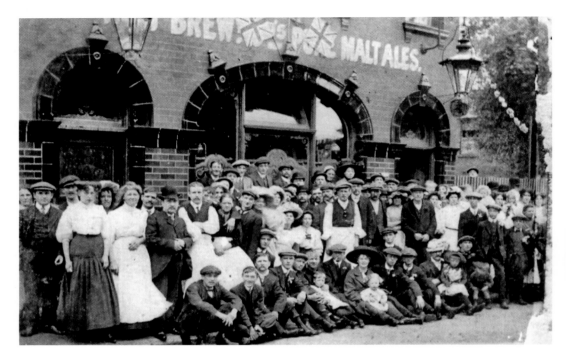

The Gate Inn
Although Ladypool Road from Highgate Road was officially part of Balsall Heath the people who lived there considered they were part of Sparkbrook known locally as 'The Brook'. Studley Street was just over this border when in 1914 the customers of The Gate public house, no doubt from both districts, posed for the photograph.

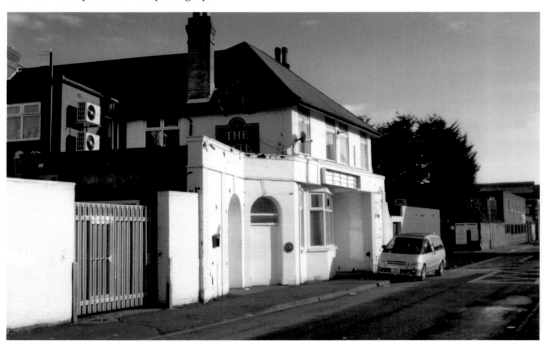

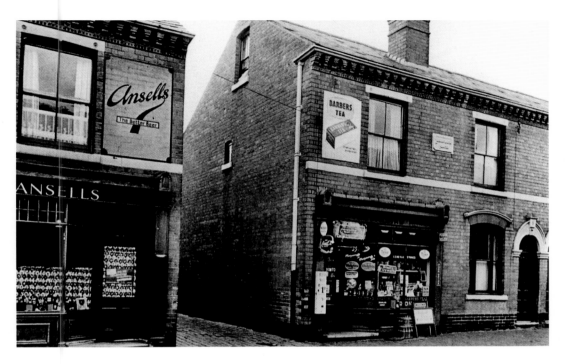

Ombersley Road

Opposite Studley Street across Ladypool Road is Ombersley Road where through time an Ansells off-licence (beer seller) and an adjacent grocery shop have been converted into two separate houses.

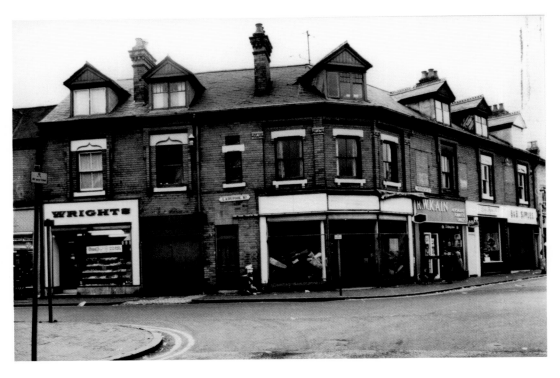

Ladypool Road – Ombersley Road

Time has brought very little change to the properties on the corner of Ladypool Road and Ombersley Road. A dental surgery now occupies the premises that carpets were once sold from and the other shops appear to have different owners.

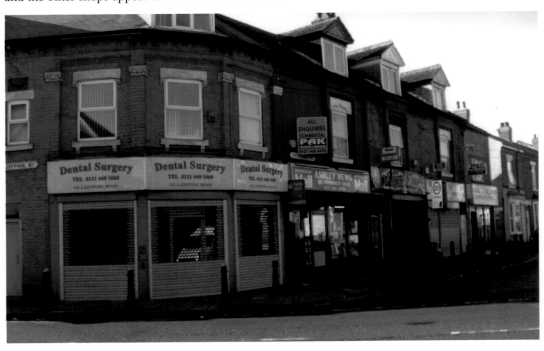

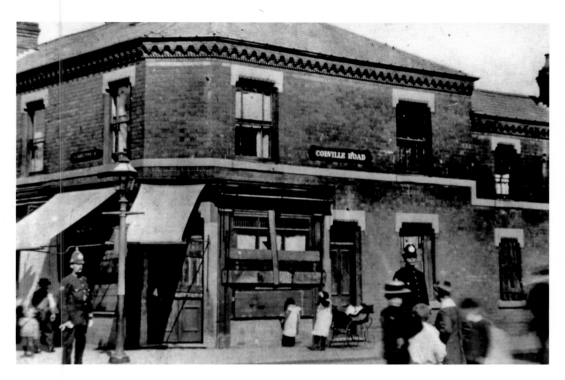

Colville Road

In the early photograph police appear to be guarding the boarded up shop on the corner of Ladypool Road and Colville Road where young children are gathering – two peeping through the boards. The same building in January 2010 has the title Lahore Village displayed above the shop front in large silver letters.

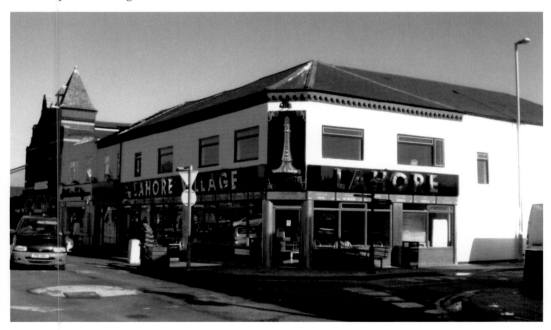

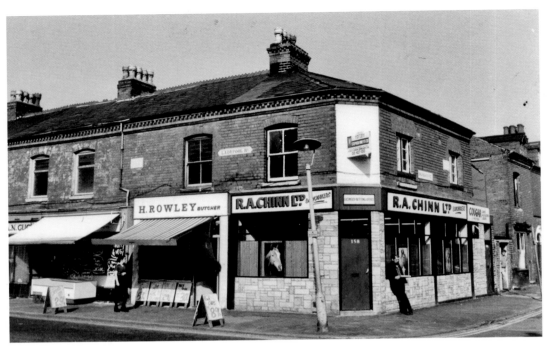

Brunswick Road

Structurally the two shops on the corner of Ladypool Road and Brunswick Road have not altered but they demonstrate the cultural and demographic changes that have taken place in this area of Birmingham. A green open space has been created following the demolition of the houses in Brunswick Road.

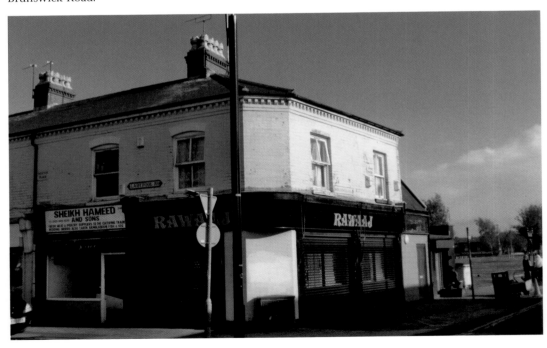

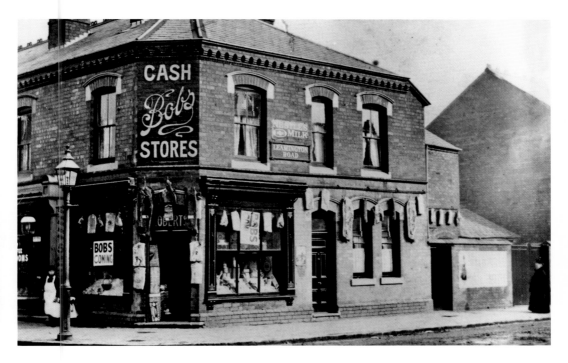

Leamington Road

Next door to the dining room shop two signs in the window state 'Bob's Coming' and joints of meat (are they for Bob?) are hanging on the wall outside Bob's cash store on the corner of Ladypool Road and Leamington Road. Today Imran tyres are sold from there.

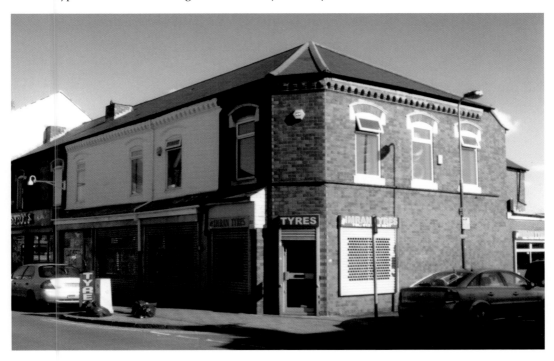

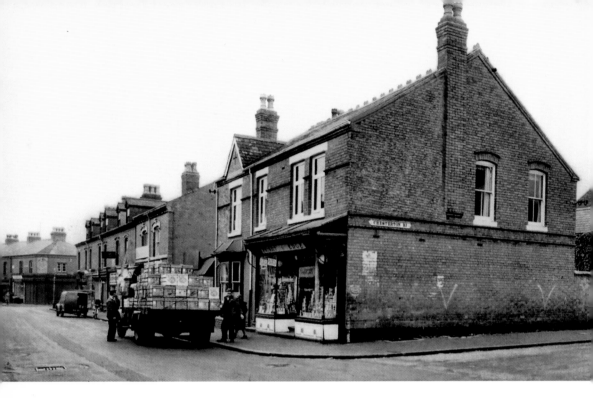

Chesterton Road

Very little change has occurred since the 1950s photograph was taken at this location where Chesterton Road meets Ladypool Road.

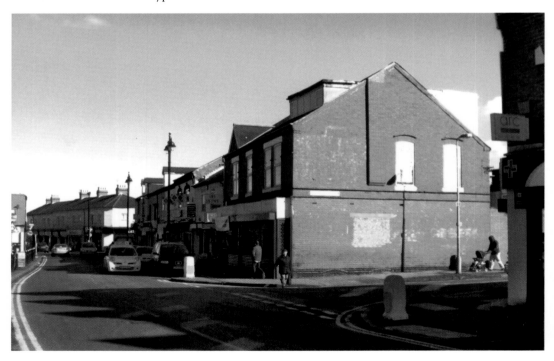

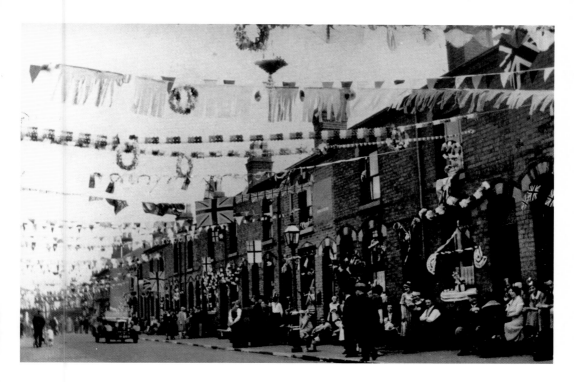

Oldfield Road

Armistice Day is being celebrated in 1919 by neighbours sitting in groups outside their back-to-back homes in Oldfield Road off Ladypool Road. Through time the road and the scene has changed greatly following the demolition and provision of new homes on one side and a green open space on the other.

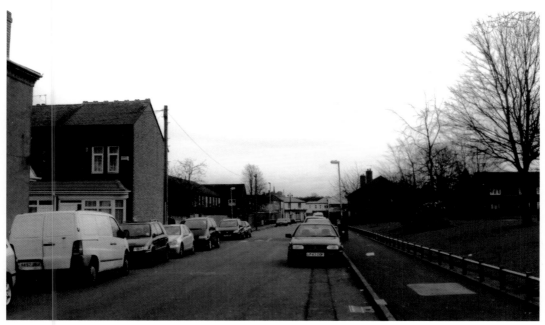

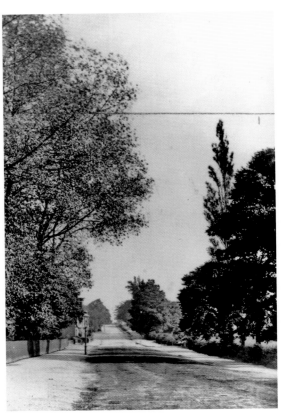

Stoney Lane

The two views of Stoney Lane looking down from Highgate Road towards Moseley demonstrates the rural to urban change Sparkbrook has endured in just less than one hundred years.

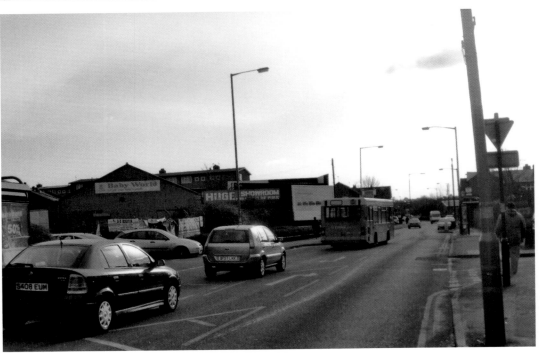

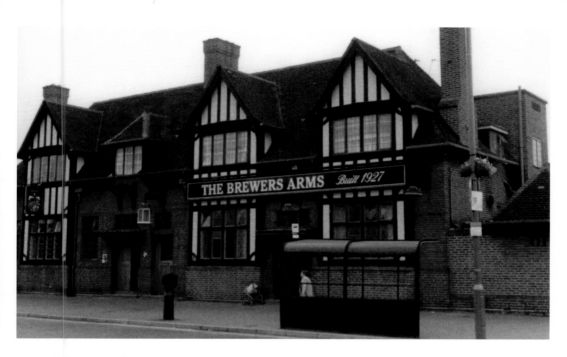

Highgate Road

The Brewers Arms public house built in 1927 on Highgate Road was a large impressive building that had a bus terminal outside where only the remains of a bundy clock are evident in the early photograph. Today the building has been painted yellow and houses the Lahore Karahi Restaurant.

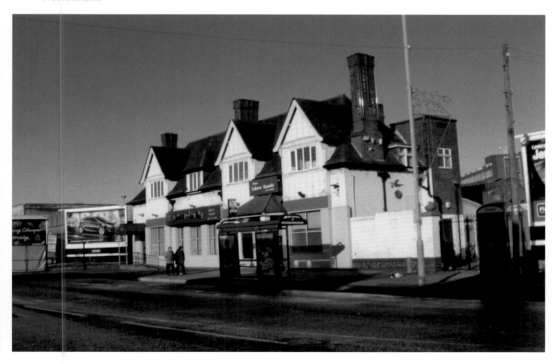

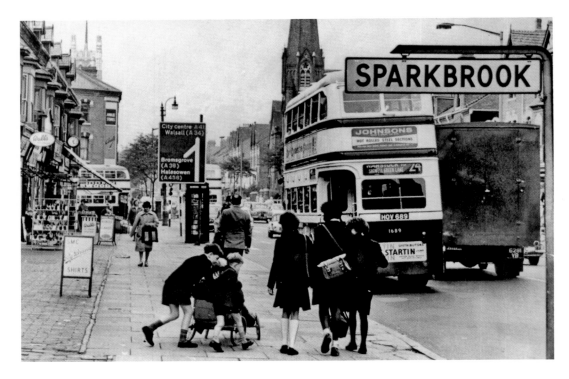

Stratford Road

Two views of Stratford Road fifty years apart at the Highgate Road/Stoney Lane junction. On the left St Agatha's church is more visible in the 2010 photograph following the removal of the Ansells property and the Baptist church on the right has lost its tower.

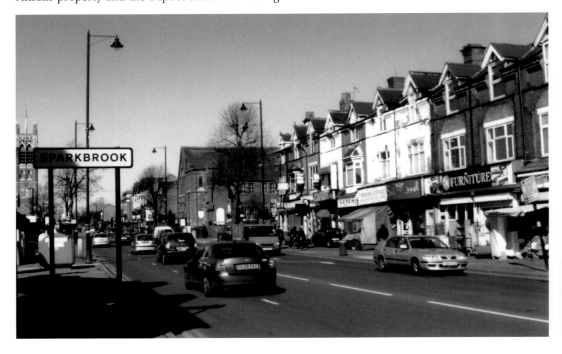

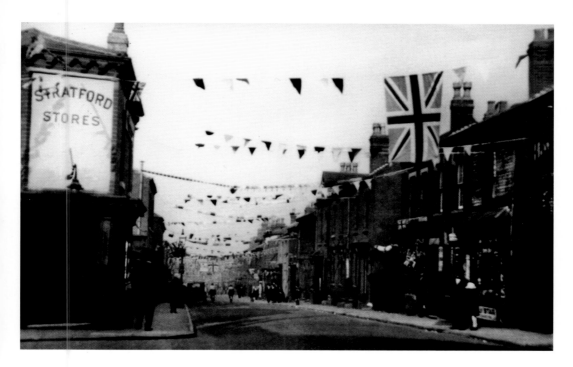

St Johns Road (Sparkbrook)

Halfway down St Johns Road from the Stratford Road flags have been erected from each side of the road to celebrate the silver jubilee of King George V in 1935. The church of St John the Evangelist designed by Martin & Chamberlain in 1881 is on the left of the 2010 photograph and the replacement for the back-to-back housing can be seen on the other side.

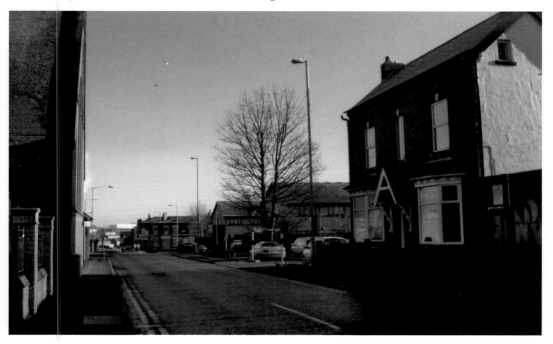

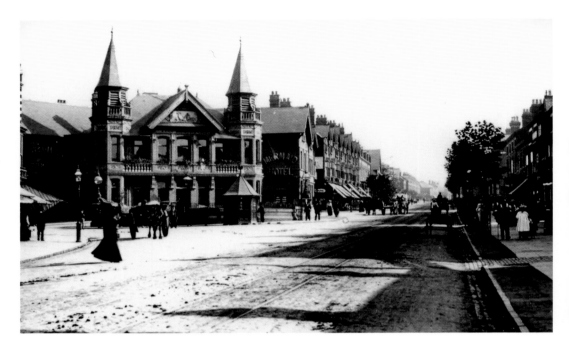

Mermaid Hotel (Sparkbrook)

An inn has stood on the corner of Stratford Road and Warwick Road since the middle of the eighteenth century. The Mermaid Hotel bathed in sunshine on the early 1900s photograph has recently been renamed The President but the former name is more familiar to the general public. The President suffered fire damage on 16 January 2010 and is presently closed.

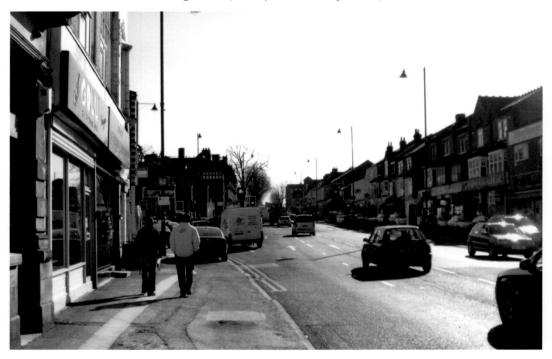

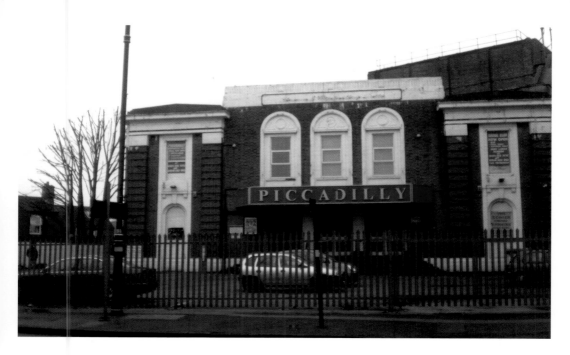

Piccadilly (Sparkbrook)

Entertainment first began at this Stratford Road site showing silent films in 1913 as the Picturedrome. The Piccadilly cinema opened here in 1930 and closed in 1972. Showing Asian films the cinema opened again in 1974 as the Dreamland and got renamed The Piccadilly once more after a short time as a bingo hall. Today the building is used as a banqueting suite called The Oval.

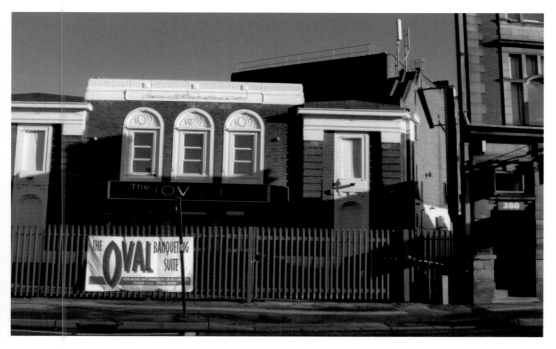

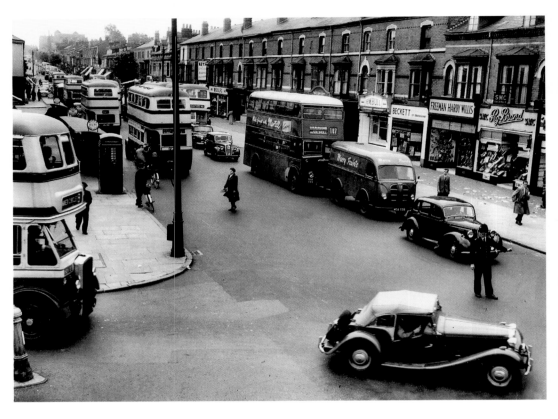

Sparkhill/Sparkbrook Boundary

A policeman controls the traffic at this very busy crossroads where Highgate Road crosses the Stratford Road into Walford Road, forming the southerly boundary of Sparkbrook. Today a set of traffic lights has replaced the policeman.

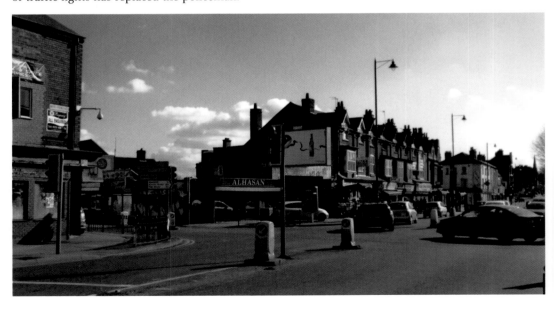

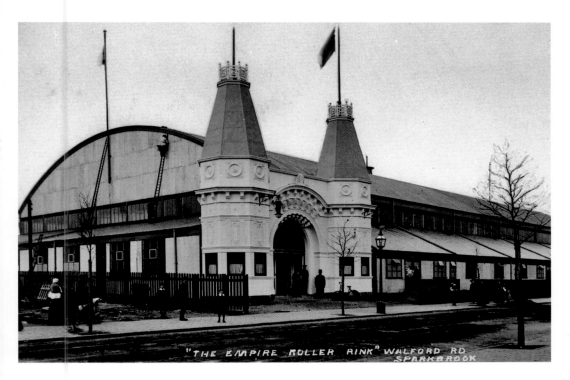

Roller Rink

From Stratford Road along Walford Road three different places of entertainment were located on the left hand side; a cinema, a snooker hall and the famous Empire Roller Skating Rink. The Sorath Prajpati Community Centre, in the 2010 photograph, has taken over the cinema, the snooker hall is still functioning but the roller rink has been demolished and replaced by a small housing estate.

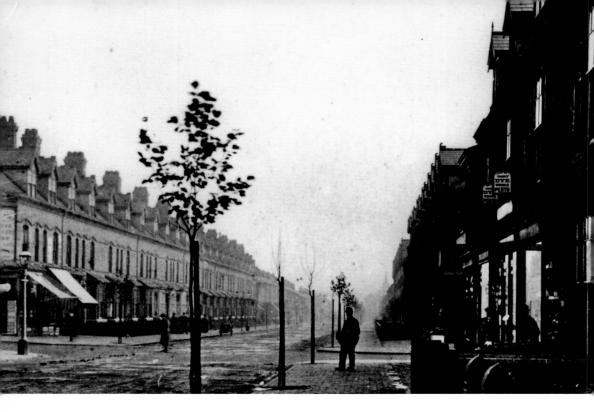

Walford Road

Walford Road at the Medlicott Road junction remains the same with very little external development.

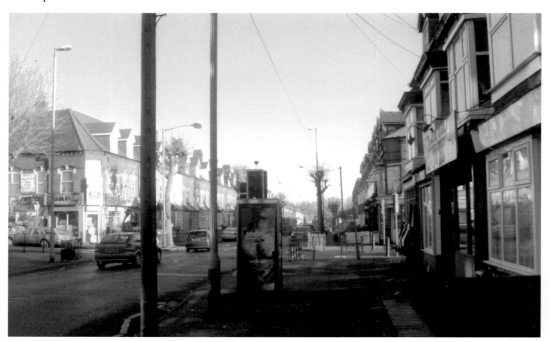

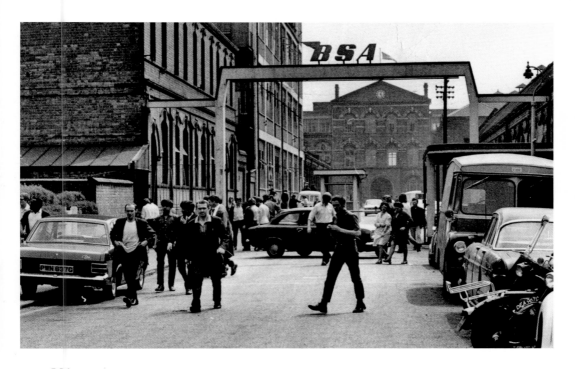

BSA

The world famous British Small Arms (BSA) company located on Golden Hillock Road and Armoury Road producing guns over the years for the military and the sporting world, cycles and motor cycles. The factory closed, and the extensive buildings have been demolished leaving no trace of its former greatness.

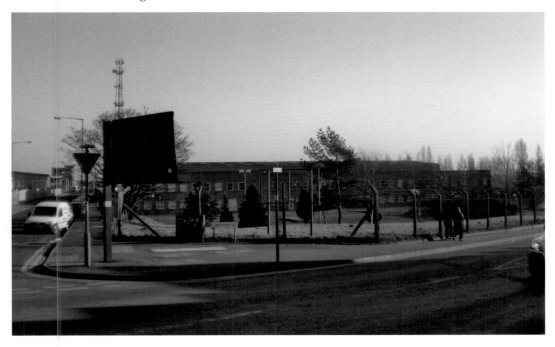

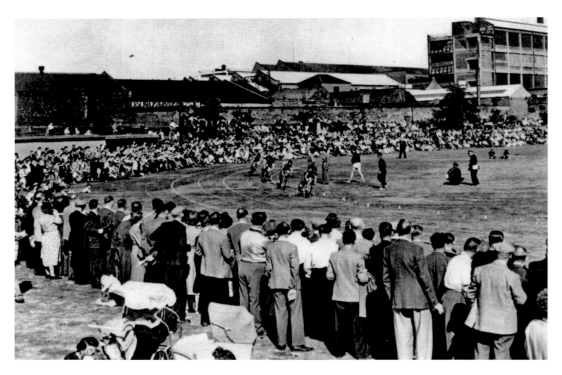

BSA Sports Ground

Behind the former BSA buildings a sportsground existed for the use of BSA employees. A sports event is shown in the early photograph that was supported by many workers and their families. Sadly the sports ground has gone the same way as the factory leaving an open green space behind.

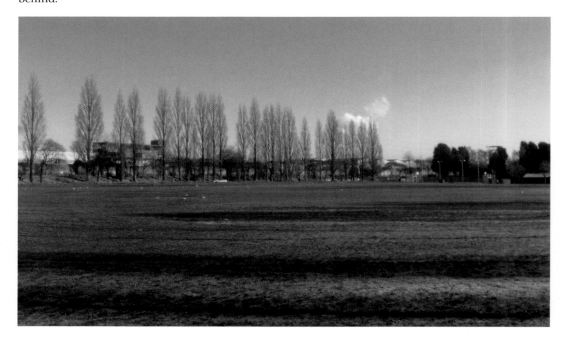

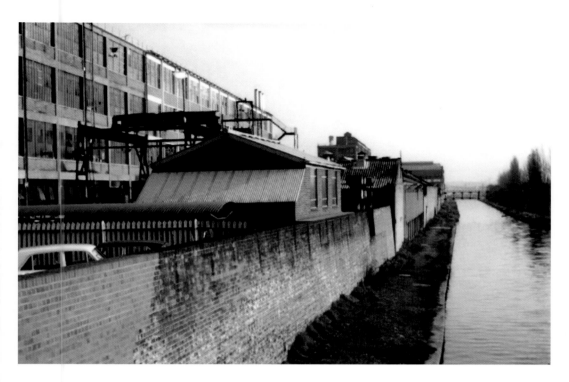

Warwick and Birmingham Canal
The Warwick and Birmingham canal passed alongside the main BSA factory viewed from Golden Hillock Road in the early photograph and without the factory in the 2010 view. The Anderton Road Bridge can just be seen in the distance.

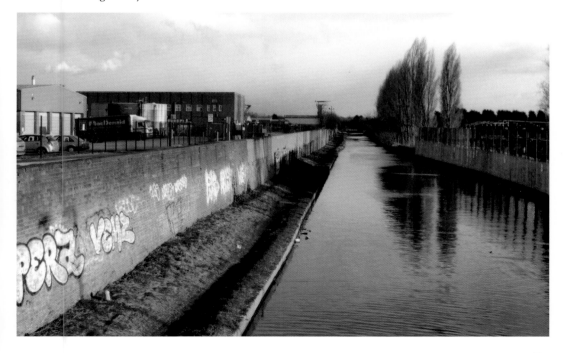

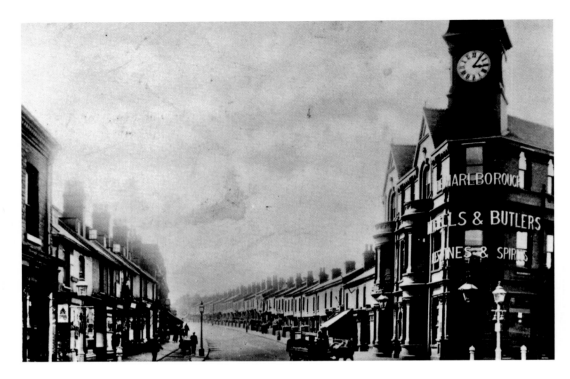

The Marlborough

The Marlborough designed by William Jenkins was built in 1900 of brick and terracotta with an imposing clock tower. The Marlborough was built as a Mitchells & Butler (M&B) public house on the junction of Anderton Street and Montgomery Street. The houses immediately adjacent appear to be the only changes that have occurred in the past one hundred and ten years.

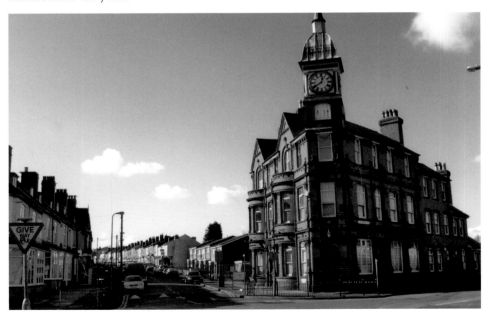

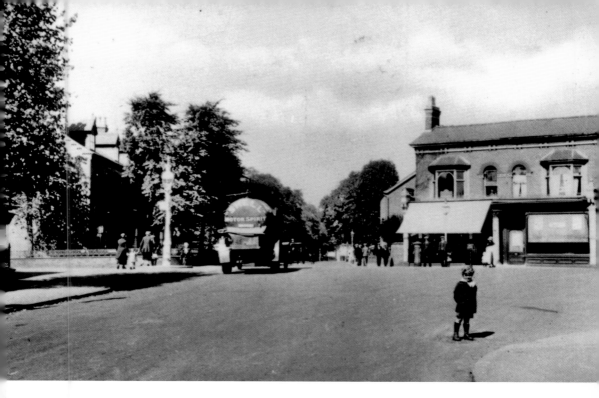

Six Ways
Glovers Road, Cooksey Road, Waverley Road, Wordsworth Road and both sides of Golden Hillock Road meet here. The buildings remain the same but the traffic has increased considerably.

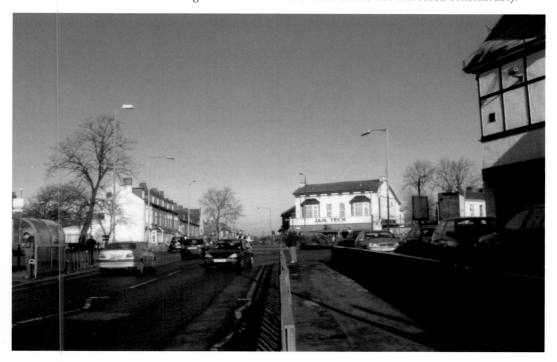

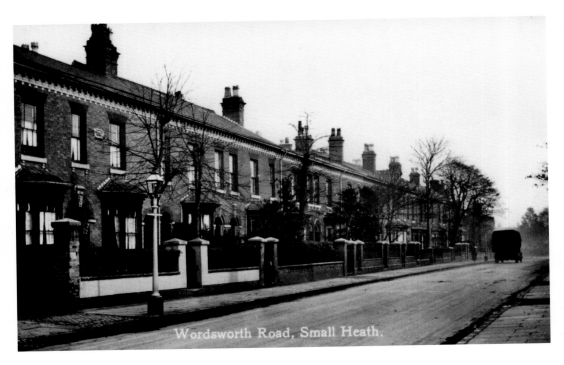

Wordsworth Road, Small Heath.

Wordsworth Road

Wordsworth Road forms a boundary road at one end of Small Heath Park. The houses were built to house middle class families in the early 1900s, and their appearance between the two photographs remains largely unaltered.

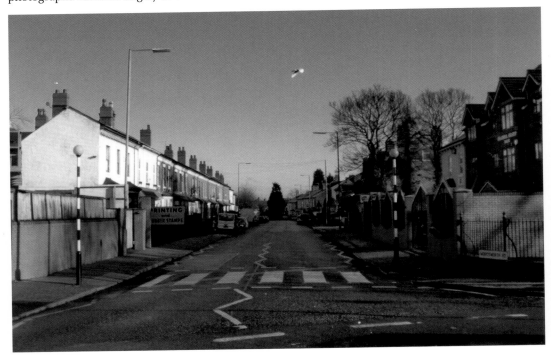

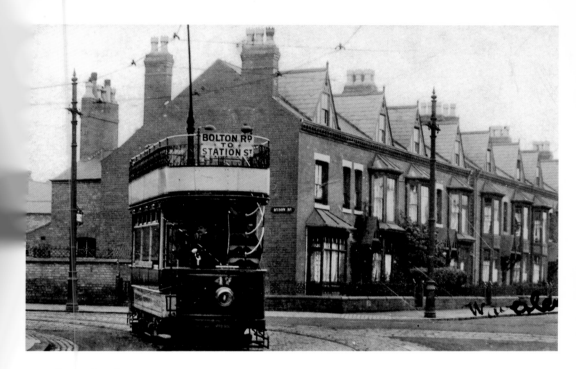

Byron Road

The number 22 tram is leaving Byron Road passing Waverley Road *en route* to Birmingham city centre. This route was discontinued by 1922. By 2010 a bungalow has replaced some houses from this corner.

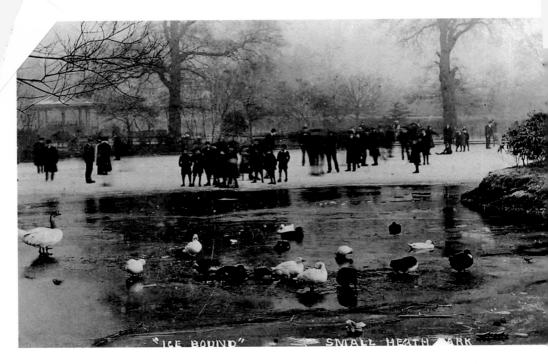

Frozen Park Pond

A postcard of the pond in Small Heath Park is entitled 'Ice Bound' where people have gathered to view the birds walking on the frozen ice. A similar scene was found in January 2010 where two loaves of sliced bread were being offered to the geese walking on the frozen water.

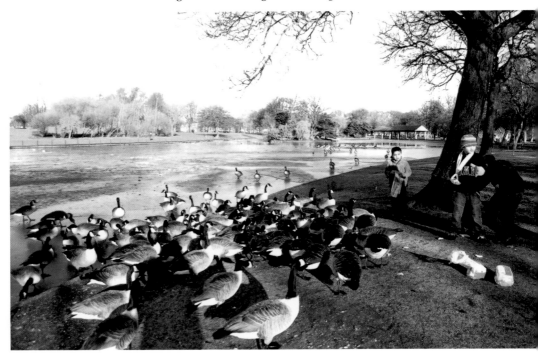

94

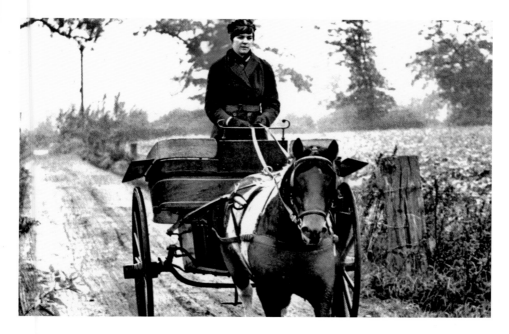

End of The Journey

This photograph was donated to the Carl Chinn archive. Miss Heather Bradley is on her rounds as a trainee midwife travelling through Small Heath in a pony and trap, possibly in Small Heath Park. The final photograph taken in February 2010 concludes the journey around Small Heath that began at the park. In 1963 the fourth shop from the park entrance was used as a fish and chip shop called The One by the Park. The owners Mr and Mrs Hassan were among the area's early demographic changes as they were both immigrants from Cyprus. They ran a very successful business, and large queues stretched as far as the traffic lights near David Creswell's shoe shop each November when the annual bonfire and fireworks display was held in the park.

Acknowledgements

The Authors of *Small Heath & Sparkbrook Through Time*

Ted Rudge www.winsongreentobrookfields.co.uk and Keith Clenton a volunteer on the Carl Chinn archive team acknowledge that the completion of this book has been made possible by the generosity in time and materials from many people and if any are missed in this acknowledgement we apologise.

We thank the following website and people who have helped in this project.
Professor Carl Chinn; http://lives.bgfl.org/carlchinn/ for allowing us to use photographs from the "Carl Chinn Archive" and for writing the foreword to our book. To the dedicated group of volunteers that compile the Carl Chinn archive for their help and support. The Birmingham Co-op History Group, the Small Heath History Society, Mac Joseph and John Houghton for their help with some of the old photographs. To Mark Norton (www.photoboydjnorton.com) supporting Asthma UK. To Pat Bassett for supplying the photo and the information of her father E. R. Harris and his Coventry Road Shop and to Chris and Beverly Platt for the Bedford Road photograph.
To Ted's wife Maureen for proofreading all the text in the book and for her full support for the project. Keith would also like to pay a special thanks to his wife Doreen for her sufferances when the photographs were taken.
We would both finally like to thank Amberley Publishing for giving us the opportunity to produce this local history book and to everyone who reads the publication we trust it rekindles memories the way it was or still is for you.

Ted Rudge M.A. and Keith Clenton

Other Birmingham Through Time Amberley Publications

Winson Green to Brookfields Through Time by Ted Rudge
In and Around Ladywood Through Time by Ted Rudge
In and Around Aston Through Time by Ted Rudge and John Houghton
Birmingham Up Town Through Time by Ted Rudge, Mac Joseph and John Houghton